Stephen Deutch, Photographer

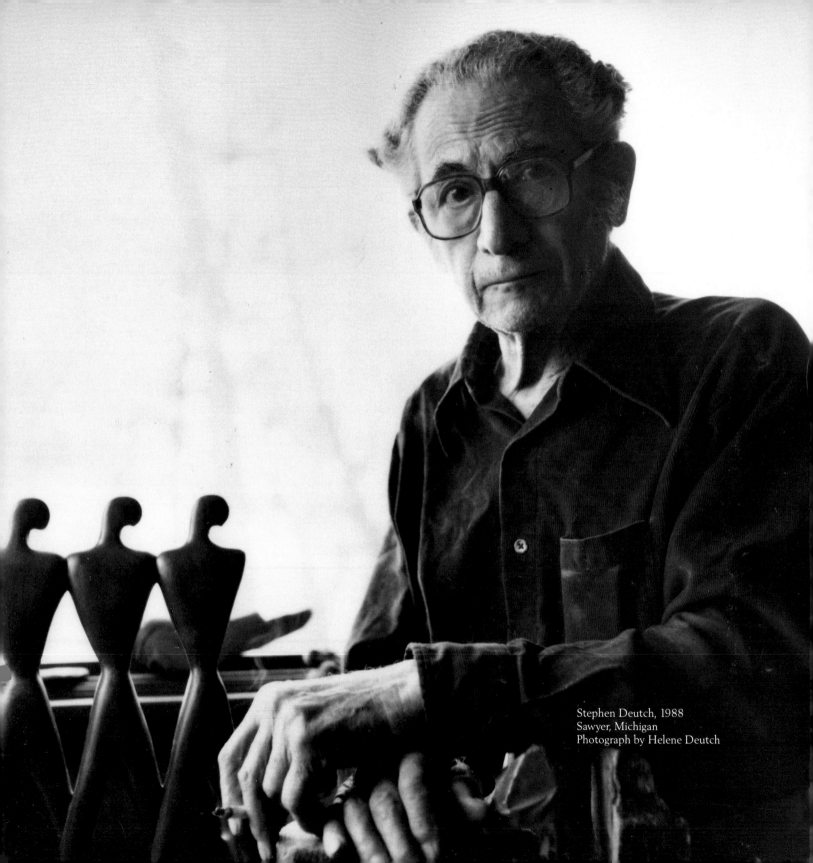

Stephen Deutch, 1988
Sawyer, Michigan
Photograph by Helene Deutch

Stephen Deutch, Photographer

From Paris to Chicago,
1932-1989

Edited by
Kenneth C. Burkhart and
Larry A. Viskochil

Foreword by Studs Terkel

Essay by Abigail Foerstner

TriQuarterly Books/Another Chicago Press
in association with the Department of Cultural Affairs,
Chicago Office of Fine Arts and the Chicago Historical Society

Copyright © 1989 Stephen Deutch
All rights reserved.

TriQuarterly Books are published by
Another Chicago Press,
Box 11223, Chicago IL 60611.

Funded in part by grants from the
Illinois Arts Council and the
National Endowment for the Arts.
Additional funds from Leo Burnett, USA.

This book has been published
with the assistance of the
TriQuarterly Council.

TriQuarterly Books
Reginald Gibbons and Susan Hahn, codirectors
Northwestern University
2020 Ridge Avenue
Evanston IL 60208

Photographs for the book printed by
Gamma Photo Labs, Chicago.

This book has been produced in
conjunction with the exhibition
Stephen Deutch, Photographer:
From Paris to Chicago, 1932-1989
at the Chicago Public Library Cultural Center
November 11, 1989—January 6, 1990.

ISBN: 0-929968-05-0 (cloth)
ISBN: 0-929968-06-9 (paper)

Library of Congress
Catalog Card Number:
89-85386

Distributed by
ILPA, Box 816, Oak Park IL 60303

Dedicated to Helene

Contents

On Seeing Stephen Deutch's Photos

Studs Terkel

I've traveled with the poor
I've traveled with the rich
And I'll be a-travelin' on…

So goes an old American folk song: of the traveler who has observed the human comedy, who has seen everything. And sings it out.

Steve Deutch, with his camera eye, captures the whole scene, too, as lyrically as the singing traveler. He sees it, feels it and snaps it. In the process, as you're held fast by what he saw, you feel it, too. In his giftedness, his own vulnerability is revealed. And ours. It is the mark of the artist.

Ever since his Paris days, 1932, when he captured the conspicuous waste of a fancy Rothschild ball and another kind of waste—*clochards* sprawled on the sidewalk—Deutch has been going about his job.

It was in Chicago, where he has worked for more than fifty years, that he caught life, full-face: in all its power and glory and pain. Like his dear friend, Nelson Algren, he saw the tragicomic face of a clown city; and in his portraits of Mahalia Jackson, he saw its radiance. Yet it is in the anonymous many that he saw all its attributes.

Just for the record, Deutch has been a top-flight commercial photographer. His work for advertising agencies, public relations firms and industries has won all sorts of honors and awards. High fashion, high skyline and high-up makers and shakers have been well observed by Deutch, and well served.

But Herman Kogan, Chicago's quintessential journalist, also saw the lasting value of Deutch's photos. The series "Twilight World," which Kogan helped place in *The Chicago Daily News*, was a coup for the newspaper, and was nominated for the Pulitzer Prize.

"I like people as they are, as they are found," Deutch said, on the occasion of his celebrated bench-sitters series. Aside from Edward Hopper

and his use of light in accentuating loneliness, I know of no one else who has so poignantly captured that feeling as Deutch does in his bench people. We see two elderly ones sharing a park bench, yet they are at a distance from one another: far apart and back to back. In the background, casually dominant, is a sports-car dealership; "JAGUAR" is the only word we see. It is enough. At the school for retarded children, we see one: she has bedecked herself with assorted dolls as elegantly as a young society matron in sable furs. She, too, is someone to reckon with. At least to Steve Deutch. Once again, he sees people as he finds them.

Inanimate objects are not alien to him either. "Doors and Windows," in a series of that name, come alive. We are curious: what or who is behind them? We see whiskey bottles in the display window; up above, partially obscured by black curtains, peeks the legend: "FUNERAL DESIG—." I doubt whether the WCTU commissioned Steve to catch this one, yet they couldn't have said it better. Not that Steve is averse to a drink now and then. It's simply that truth catches him and, artist that he is, he can't deny it.

Time passing, fashion changing—after all, he's captured half a century—is another of his passions. A dray horse, attached to a wagon, is nibbling at a torn box of lettuce on the curb. Glowering at the feast is one headlight of what appears to be a fancy car of the thirties. Move on, Dobbin, you're past your prime, time for early retirement.

We see a booze parlor of time past. A window sticker reads: "Premium Beer, 7 Ounces, 10 Cents." Another: "Prager, 22 Cents, A Full Quart." A grizzled patron is wheeling away his treasures in a broken-down baby buggy. Gone are the days, Maggie....

Yet, Deutch's genius is in fusing past to present. There's a familiar sight: a homeless one, curled up, fetal fashion, against the wall of an abandoned factory. Was this photo taken Then or Now? Is Steve trying to tell us something?

Look at that old scene at the LaSalle Street Station. A red cap is helping someone off the day coach. He doesn't have to, but he does it. It evokes for me a personal memory of my arrival in Chicago at the age of eight. LaSalle Street Station. I leap into my brother's arms. A red cap is beaming. Steve Deutch brings it all home again.

How can we leave this work without Steve's sign of Chicago's public, raffish face? It is a ward heeler posed against the window of a polling place. The poster: Primary Election, Tuesday, April 14th, 1964. He is chewing at a cigar. He is studying something out of camera-range. Is he watching a live one enter? Is he counting? He's biting hard on his stogie. He exudes confidence. Or does he? Deutch has us wondering. And mesmerized.

Steve Deutch has traveled a long way and on the journey has taken us with him. It's been worth the trip.

Introduction and Acknowledgments

Stephen Deutch occupies an unusual place in the history of photography. Deutch is one of the few photographers who succeeded in the highly competitive field of commercial photography while at the same time earning widespread recognition and gaining personal satisfaction in his editorial and artistic photographic work. Major advertising agencies sought him out for his visual expertise, and Deutch gave them photographs of stunning realism matched only by his artistic endeavors. Born in Budapest, Hungary, in 1908, Deutch studied sculpture at the Royal Academy of Fine Arts in Budapest in 1926. Beginning in the early 1930's he applied his training in three dimensions to his life's work: images that span advertising, photojournalism, documentary, travel, portraiture, and art photography. His compassion for humanity and his astute aesthetic vision are evident in each of these seemingly separate areas of photo-graphic investigation, and Deutch now can be placed in historical confluence with his contemporaries.

Stephen Deutch, Photographer: From Paris to Chicago, 1932-1989 is a collaboration between the Department of Cultural Affairs, Chicago Office of Fine Arts and the Chicago Historical Society. The images in the exhibition and the selections for this book were chosen from the more than 10,000 photographic prints, transparencies, and negatives that compose the Stephen Deutch Collection in the Prints and Photographs Collection of the Chicago Historical Society. Although some of the images were made for commercial clients, as social statements and as artistic expressions they reveal much about Chicago's history and the city's development over the past fifty years.

Many individuals have helped bring this project to fruition. Stephen Deutch, a rare individual dedicated to the highest humanist

goals, has been a joy and inspiration to work with. His commitment to making this exhibition and book possible is one measure of his love of photography and a lifetime of dedication to the medium as a tool of many possibilities. For all these reasons he has our deepest appreciation and respect.

Our special thanks goes to Abigail Foerstner, whose thoughtful and insightful essay for this book provides the first comprehensive writing on the life and work of Stephen Deutch. And we are extremely grateful to Studs Terkel for his wry and poignant foreword to this volume.

Ellsworth H. Brown, President and Director of the Chicago Historical Society, and Susan Page Tillett, Director of Cultural Affairs, were enthusiastic supporters of this collaborative effort. We are indebted to Russell Lewis, Director of Publications at the Society, for his many helpful editorial suggestions. We are also grateful to the staff of the Society's Design Office, directed by Andrew Leo, and to John Alderson, photographer, and Jay Crawford, photo technician, for their contributions to both the exhibition and the book. Special recognition for

processing and cataloging the Deutch archive goes to Diane Ryan, Maureen O'Brien Will, Linda Ziemer and Margaret Callahan of the Society's Prints and Photographs Department.

Major support has come from the Department of Cultural Affairs by Joan W. Harris, Commissioner; Ronald L. Litke, Assistant Commissioner/Communications; Joan F. Small, Director of Development; and Linda Wedenoja, Coordinator of Cultural Center Publicity. At the Chicago Office of Fine Arts, our thanks go to Madeline Murphy Rabb, Executive Director, and Janet Carl Smith, Deputy Director, for their continued support. In addition we tip our hats to Gregory Knight, Director of Visual Arts, and Edward Maldonado, Assistant Curator of Exhibitions, at the Cultural Center for their considerable assistance.

We especially wish to note the ongoing support to Cultural Center exhibitions by Commissioner John B. Duff, his cabinet and the Board of Directors of the Chicago Public Library, as well as the efforts of Christine Jones, Head of Graphics; Markus Dohner, exhibit designer; and Tom Mikula, typesetter.

We are especially appreciative of Lee Webster and Judi Biss of Another Chicago Press and Reginald Gibbons and Bob Perlongo of *TriQuarterly* magazine for their extraordinary efforts in coordinating the design, production and distribution of this book. We are also indebted to Raymond S. Machura for the elegant design of this book.

Finally, we are grateful to the Illinois Arts Council, a state agency, for its ongoing support to our exhibition programs. Additionally, Leo Burnett, USA has provided key funds toward the completion of this project, and we extend our sincere thanks. The City of Chicago has provided continuous support through the Department of Cultural Affairs, Chicago Office of Fine Arts, and the Chicago Public Library; for this special support we are most appreciative.

Kenneth C. Burkhart
Curator of Exhibitions,
Department of Cultural Affairs,
Chicago Office of Fine Arts

Larry A. Viskochil
Curator of Prints and Photographs,
Chicago Historical Society

Sculptor of Light

Abigail Foerstner

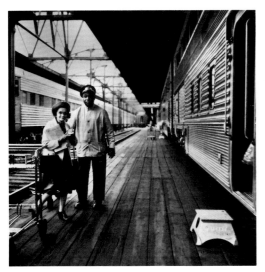

Red cap helping passenger at LaSalle
Street Station, c. 1965
Chicago

Stephen Deutch came to Chicago from Paris in 1936 with a successful photography career already established and a signature vision of how a photograph should look already apparent. He was twenty-eight years old. He never gave in to the flat surface of the photograph. He choreographed lighting, form and depth of field to capture a three-dimensional, sculptural perspective. Deutch followed his own aesthetic instincts whether he photographed a celebrity posing in the studio or ordinary people sitting out life on a park bench. The only photographer who really influenced him was his wife Helene Deutch, who taught him to take pictures, as they struggled to stay on top of a mountain of work at the commercial photography studio she took over in Paris.

Ask anyone who knows him to describe Deutch and they will tell you about his hands—large, rough sculptor's hands. He was a sculptor, "born with a chisel," as he puts it. He became a photographer. He always wanted to be a musician. His photographs are rhythmic like music, polished like sculpture. "I was a pretty good photographer. With his sense of lighting, Steve brought everything alive," says Helene. Still, the potent emotional pitch echoes from spaces in the pictures illuminated only by his passion in making them. Deutch often talks about *making* a photograph, engaging one's whole being in the process, rather than taking a photograph, an act he associates with just grabbing at haphazard bits of life. "He had what we call 'good eyes,'" notes long-time friend Don Kassel, a painter and creative director in Chicago advertising. "What amazed me most was his portfolio. His wasn't a one-year portfolio. It wasn't hip. It was a chronology of work in the city. It was beyond anything brought to my desk."

Fiercely independent and unpretentious, Deutch hated to sell his work. But often just showing the

portfolio to a prospective client was enough. He did countless fashion assignments for Marshall Field's and Carson Pirie Scott & Co., slice-of-life vignettes for Abbott Laboratories and the First National Bank of Chicago and coolly elegant product shots for Container Corporation of America, to name just a few clients. He published editorial photographs in magazines that included *Fortune, Saturday Evening Post, Ebony, Popular Photography* and *Coronet.*

Deutch's daughters Annick Smith, Katherine Deutch Tatlock and Carole Deutch came often to his studio at 75 East Wacker Drive, soaking in the mysteries of woman-

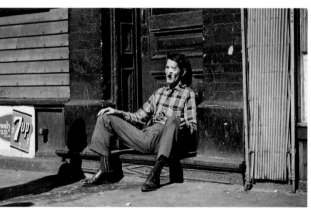

Recovering,
"Doors and Windows" series, c. 1955
Skid Row, West Madison Street, Chicago

hood with the smells of perfume and pancake make-up as models prepared for fashion shoots. "Look at that!" Outside the studio, the sisters heard the phrase from one parent or the other at every street corner in Chicago. They traveled cross-country in a Buick their father drove top speed and, at every stop, they heard, "Look at that!" But the credo also describes the weave of some inner visual fabric they share because all three daughters have become filmmakers. In 1979, Kathy completed *Pista: The Many Faces of Stephen Deutch*, a revealing film about her father that takes its title from the Hungarian nickname for Stephen. One segment records a half playful, half serious joust of a conversation between Deutch and his close friend Nelson Algren. "This is where you and I differ," Algren says in the film. "I'm not going to give up anything for the sake of security because that's like giving it up for the grave." But they didn't really differ, as Algren knew. Deutch was constantly warring within himself between his highly successful commercial photography and his art. He took to the streets of Chicago and streets around the world to find the universal statements of human life that photography could narrate.

Deutch and Helene opened their first studio in Chicago within weeks of their move to the city. They had arrived during a remarkable era of American photography. In 1935, a corps of photographers began roaming the country in what would become an eight-year odyssey to

record the ravages of the depression for the Farm Security Administration. *Life* magazine was born in 1936. László Moholy-Nagy, a Hungarian like Deutch, opened a design school in Chicago in 1937 that would evolve into the Institute of Design at the Illinois Institute of Technology. Moholy transplanted there the European Bauhaus view of photography as a forum for experimental expression and nurtured the medium as a fine art.

Increasingly, art, commercial and editorial photographers divided into distinct camps. On the commercial side, stiffly posed pictures replaced drawings to illustrate the sing-song product slogans of the day. Free from the competition of television, major cities supported several daily newspapers employing packs of photojournalists who elbowed their way to the front lines of news events and met every train with a movie star aboard.

Most photographers signed up for a career in the arts, the studio or on the streets as photojournalists. But Deutch straddled all three camps with his magazine photo essays about Lena Horne, Joe Louis and Duke Ellington and his maverick studio style that gave commercial shots an unstaged spontaneity. Most poignant of all was his work as an artist on self-assigned projects that captured the life of a city from its blustering politicians to its mentally wounded. From start to finish, from Paris to Chicago, he sculpted with light in photographs that tell a story of the connectedness of all things.

Stephen Deutch with
woodcarvers, c. 1920
Budapest

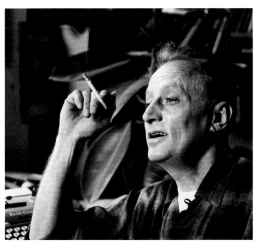

Nelson Algren, 1965
Chicago

Beginnings

*My oldest brother became a lamp
fixture designer. He worked for a big
company in Chicago and made orig-
inal drawings for new fixtures and
that company he worked for got a
large commission to do the Civic
Opera House. A lot of the light fix-
tures at the Civic Opera are designed
by Alfred Deutch, my brother. Becom-
ing an artist started with Alfred
as an act of rebellion. It was taken
up by my brother Gene who was
trained to be a carpenter but, not
satisfied being a carpenter, got into
this wood inlay business. And then
here I was. I can't myself just become
a shoemaker. So that's how I decided
to become a woodcarver and there,
I wasn't just satisfied being a wood-
carver. I wanted to be a sculptor,
which is different. So I left Budapest.
The dreams were to develop myself
as an artist, a sculptor in Paris.*

Stephen Deutch
1989

Deutch grew up in Budapest where
his father Julius was the caretaker
for a business club in the political
and social tumult of Hungary prior
to World War I. Men gathered at
the club to play cards and drink cof-
fee made by his mother Johanna.
The family lived in a tiny apartment
behind the club, and Alfred, Eugene
and Stephen ran the coat-check
room because club patrons gave the
children more generous tips.

Life was a struggle. Working-class
families made ends meet by buying
"delicacies" such as chicken feet and
necks for soup. Johanna served the
soup every Friday after temple ser-
vices. The temple and the Jewish
faith were the centers of her hus-
band's life, a center she and her sons
didn't share, and one that cut a deep
chasm in the family.

Alfred, six years Stephen's senior,
left home in rebellion against his
father's staunch religious precepts.
Schooled at a business college, he
took a job as a bank clerk in Buda-
pest but then rebelled against that
safe and secure livelihood and turned
to the arts. The decision profoundly
redirected the course of his broth-
ers' lives as did his decision in the
early 1920's to start a new life
in Chicago where an aunt and
uncle already had immigrated. "My
daughters question to this day, 'Was
there any precedent for the arts in
the family?' No, there was none. My
father and mother probably had less
education than I and I only finished
eighth grade. They were not inter-
ested in art. I don't think they ever
went to a museum or an exhibition
until the time they came to Chicago,"
Deutch says.

Eugene, trained as a carpenter,
followed his brother's lead. He began
to make original designs for wood
inlaid furniture and later became
a prominent ceramics artist. He
moved to Paris and then to Chicago
while Deutch, now fifteen, appren-
ticed as a woodcarver in Budapest.
Deutch worked at the wood shop
for three years without pay in
exchange for the chance to learn
how to carve furnishings with intri-

cate designs. But much of the apprentice's job amounted to clearing the drifts of sawdust and shavings that covered every surface. As a bonus, the boss sang the arias of the great operas while working.

During those years Deutch began to model clay figures and carve wood ones for himself with the rudimentary tools he acquired for his apprenticeship. In his sculpture, he began to interpret the human body as sensual yet abstract folds of form. Later, the dramatic shadows and highlights he cast on the body with lighting created a similar effect in photography.

The young woodcarver's sculpture began to appear in group exhibitions in Budapest, and a wealthy uncle offered to send Deutch to the city's Royal Academy of Fine Arts where Miklos Strobel, Hungary's renowned sculptor of public statues, taught art as though it were a military drill. "I didn't like what he did and I didn't like the whole atmosphere of the academy," Deutch recalls. He left after one year of study. In addition to his personal qualms about the school, his parents needed help. His father had lost his job and had only the small earnings he could make cobbling shoes in his kitchen. Deutch began to support his parents once he was hired for pay by the woodcarving shop where he had apprenticed.

He continued to sculpt on a modeling stand in his bedroom and to submit work for exhibition. He wrote a review of a large exhibition that drew hundreds of entries in a sculpture competition for a memorial for Hungary's beloved poet Ady Endre

shortly after his death. Budapest's largest newspaper published the review. With credits as both a sculpture and a writer, Deutch decided it was time to go to Paris, the mecca for the arts. He was nineteen years old.

Paris

Deutch arrived in Paris in 1927 and took a small room in an inexpensive hotel. This was Paris in an era when Gertrude Stein held her legendary salons and Left Bank artists gathered at the Café du Dome. Brassaï, Henri Cartier-Bresson and André Kertész roamed the streets of the city with their new, compact 35-millimeter cameras and published their photographs in the picture magazines that were sweeping across Europe.

Deutch began to work as a woodcarver, copying baroque and renaissance patterns on furniture to earn a living and send money home. He sculpted in his spare time and showed his work in group exhibitions. He lost his job when an economic depression struck and the furniture factory that had hired him went out of business. He could find only occasional jobs as a woodcarver after that. Eating became rather occasional as well. He cooked noodles or rice on a hot plate in his hotel room and suffered from chronic digestive problems linked to malnutrition.

In desperation, Deutch took a job as a salesman for a food importer-exporter whose product line included Ovaltine and a gourmet restaurant snack called "Pretz

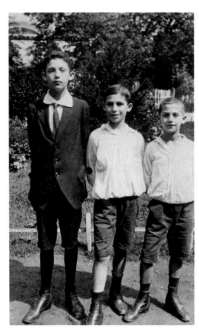

Alfred, Eugene and Stephen Deutch,
1915
Budapest

16

Sticks." When commissions slipped during the hard times, Deutch ate his wares and economized on his expenses so he could live off his travel allowance. He took third-class trains and boats instead of second-class and slept in the train stations instead of paying for a hotel. The best part about the job was that it took him all over France and also to Algiers, Morocco, Tunisia, Holland and Belgium. "I rushed to finish my sales and then went to every museum, cathedral, palace and exhibition," he says.

In Paris, he met a successful young photographer named Helene Beck who was also from Hungary. Helene arrived in Paris the year before Deutch did. She was eighteen years old at the time and moved there with her mother to join her older brother John. He was a biochemist, intrigued by the chemical magic of photography. He convinced his mother to invest in a photography studio an old school chum of his planned to open. Never the practical businessman, John's interest in the studio ended there and it was left to Helene to check up on the photographer. "I went up to the studio and right away, I got very interested in taking pictures," she says.

He showed her the basic skills, and she took a series of studio jobs, learning printing at one place, retouching at another and portrait-making at yet another. Finally, she took a job in the Paris studio of *Vogue* magazine, where she assisted in shooting pictures for editorial fashion spreads. The petite Hungarian

girl with the wistful smile suddenly had one of the most coveted photography jobs in Paris. Helene left *Vogue* to take a commercial photography position with a Paris printing firm, Deberny & Peignot, that operated a prestigious studio equipped with all the latest gear. She was working there when a friend whom Deutch was dating introduced her to him. In the movie *Pista*, Helene described him:

When I met Steve, he was the sweetest, kindest, gentlest person I had ever met—soft voice, soft spoken, very sensitive, very loving. And I never knew that I was going to fall in love with him. I just liked him. He had beautiful hands, big, strong, gorgeous hands and I took pictures of that. And he had soft, sad eyes and I took pictures of that. So, slowly, I just liked him very much, more and more and it was love.

They married in 1931, and Deutch had his first encounter with photography shortly after because Helene needed help spotting a stack of Brassaï's 16-by-20 prints for his book *Paris at Night*, published in 1933. The photographers who, like Brassaï, trailblazed the use of the 35-millimeter camera in Paris in the 1920's, worked with slow-speed film and unforgiving emulsions. Large-format enlargements like Brassaï's were grainy at best. "Do you know what spotting is? I didn't," Deutch recalls. "But Helen had a stack of prints this high, 16-by-20 blow-ups, and all looked like the moon exploded. There were so many white blank

spots and black spots or scratches and I got the job of spotting those prints. I went blind."

Soon after, Deberny & Peignot went out of business, and several of the firm's clients promised Helene continued assignments with them if she would reopen the studio elsewhere. She agreed and was able to start up with the equipment Deberny & Peignot owned and sold to her for almost nothing. Stephen quit his job to work at the studio they opened in 1932 at 9 Rue de Montsouris, and Helene taught him photography.

They lived as well as worked in the airy one-room studio in Montparnasse, a neighborhood that drew in many of the contemporary artists in Paris. A platform bed strewn with pillows for a daytime couch and a few of Stephen's pieces of sculpture made an inviting reception area of the living space.

The pictures from those days bear the stamp "H. E. Deutsch," the initials standing for Helene, of course, and Etienne, the French for Stephen. (They dropped the "s" in Deutch to simplify the spelling of their last name when they came to America a few years later.) Many of their studio photographs from Paris and their early years in Chicago were collaborations. Helene would operate the camera and Deutch would design the sets, poses and lighting. Deutch intuitively used lighting to articulate in photographs the three-dimensional language of sculpture. When taking photographs outdoors photographers always prized the long shadows and mood-laden

atmosphere of the early morning and late afternoon. Deutch set his lights to evoke the same atmospheric elements indoors.

The Paris advertising photographs made for clients such as fashion houses, insurance firms and wine makers are carefully staged vignettes that resemble stills from old movies. The models deliver classic cameos of character acting filled with whimsy, humor and pathos. A man lifts a wine glass as if ready to burst into song in one picture (Plate 6). A mother clings to her child as a villainous banker points to his account book in another (Plate 10).

Deutch and Helene had all the work they could handle in the studio, shooting during the day and making prints into the night. They worked sixteen-hour, sometimes eighteen-hour days. "We didn't get invited to Gertrude Stein's salons. Jean-Paul Sartre didn't ask us to have coffee with him. We were just proletarians of the business. We had name recognition in a certain circle but certainly not in the literary or artistic ones," Deutch says. "Life was the same way as it is for any working person. We had to be very diligent, put in lots of hours, and we enjoyed being successful. Bohemians we were not." Unlike many of the artists chatting in the cafes of Montparnasse or Montmartre, they earned enough to rent a large house with friends in the Paris suburbs for weekend retreats. They traveled, but also saved their money and supported Deutch's parents and Helene's mother.

Deutch photographed on location as well as in the studio and his work caught the eye of the Rothschild family that was in need of a photographer for their high-society costume ball in 1932. Always alert to the revealing moment of expression and gesture, Deutch's photographs edged beyond the formal posturing of the guests. The ball set the stage for a burlesque, and Deutch captured that note of high society miming itself, with Philippe de Rothschild himself dressed as Napoleon (Plate 9). During this period as well, Deutch initiated photographic projects that would span his whole career. He began photographing nudes, balancing statuesque form with sensual warmth. The nudes present woman as a dual ideal of the remote goddess draped in light and shadow and the flesh-and-blood person brought to life in the photograph's textural rendering of hair and skin. He explored the streets of Paris with his camera as he would later explore the streets of Chicago and began what would grow into a lifetime portfolio of travel photographs. He and Helene roamed the French countryside and its rustic villages, both of them taking pictures. He made the photographs for himself but, like the nudes, many would be published in magazines over the years.

The photographs from Paris and the countryside trips suggest how Deutch ventured beyond the postcard view of the world in search of the more potent emotional and visual terrain. He revealed the strikingly contemporary geometry of form to

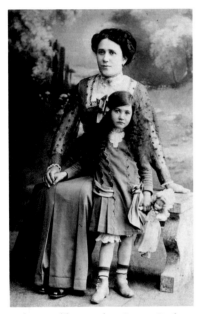

Helene and her mother, Serene Beck, 1912
Budapest

be found in the usually quaint landscape of two boats afloat on rippling water by photographing them from overhead (Plate 3). He photographed a storybook chateau beneath a sky draped in modern power lines and captured character studies of gypsies, sailors and farmers.

He was drawn to people and the way people and environments interweave intricate visual and social mosaics. He moved in close to his subjects such as the clochards, or hobos, sunning on the brick walkway along the Seine River in Paris and children utterly absorbed in a game with a simple piece of string (Plate 7).

Deutch went his own way, heedless of the salon repartee and academic debates that were reshaping photographic perspectives. Nineteenth-century photographers viewed their medium simply as a magic window to the world. But the twentieth-century mind, whether inventing cubism or quantum physics, insisted on laying bare the essentially subjective nature of viewing anything. In Germany, Moholy taught at the Bauhaus school in a mission to meld art and society for the Industrial Age. He experimented with the abstract, cameraless art of the photogram and idealized the unexplored visual frontiers of photography as a path to a new objectivity and a utopian order. More often, art photographers who experimented with new boundaries of the medium accepted the creative process as a reality unto itself. Their work reflected an underlying philosophy that what is seen is

Wedding announcement for Helene and Stephen Deutch, 1931
France

inseparable from how it is seen, and that the photographic medium is the true subject of the photograph.

But for photographers such as Kertész and Cartier-Bresson, who were pioneering contemporary photojournalism in the 1920's and 1930's, photographs could wrest universal statements from a single fleeting moment. In a world that challenged the possibility of objective reality, they trusted their own admittedly subjective vision to find and interpret such moments. Deutch didn't know Kertész or Cartier-Bresson in Paris, but, like them, he intuitively approached photography as a way of touching a common humanity with a personal vision. Even in his experimental distortions and abstract views, the intrinsic form of his subject is always apparent (Plate 17).

The Paris era came to an end after a family tragedy. Alfred, at twenty-nine years old, committed suicide. Julius and Johanna, devastated and alone in Budapest, decided to join Eugene in Chicago. En route they visited Deutch and Helene in Paris and the young couple promised to join them in Chicago as soon as possible. "I can't tell you how much I loved Paris at that time. I just didn't want to go any place. But Steve said, 'Why don't we apply for the visa? It will probably take three or four years to get it.' By that time we knew some people who are coming back and forth from Germany and they told us about the Nazis and that was a point which stuck in our minds. So, all right, we applied for the visa and

by some kind of miracle we got the visas in two months. And we were not ready to leave," Helene recalls. "We went skiing in the winter, we went boating, we went to our place in the suburbs and already at that time we thought this is the life we want. We had wonderful friends. We had a baby. So to leave it, that was really a horrible decision for me. I really cried my eyes out."

Chicago

The Deutches, with six-month-old Annick, took a steamship to New York City and arrived in Chicago by train in December 1936.

One hundred years after it was settled, the Chicago of the 1930's retained its own brand of frontier boosterism. It remained a rail hub and the hard times of the Depression made the railroads a lifeline to dreams of a better life. Farm families from rural America poured into the city along with the European immigrants who found their way from Union Station to neighborhoods as ethnic as the countries they left behind. Bosses ruled City Hall. The city's radio stations produced nationally broadcast favorites such as "Fibber McGee and Molly." The South Side had cradled the new sound of jazz and blues brought north from New Orleans. The el tracks had long since girdled the Loop. Marshall Field's and Carson Pirie Scott, the pillars of State Street, were already decades-old landmarks. The Drake Hotel and the Tribune Tower flanked the boundaries of

what became known as the Magnificent Mile on Michigan Avenue.

But Helene was not impressed. "I thought it was the dirtiest, awfullest city I ever saw. It was in December. Everything was gray and newspapers were flying around all over the streets. Oh, I thought it was filthy," she says. "I was miserable and I shouldn't have been. Gene had very nice friends, artists, very good people and they accepted us right away and they were so patient with me especially. I spoke so little English and they just really made us feel at home." The Deutches asked Gene to find them their own apartment but Gene, who was teaching ceramics as a Works Project Administration artist, decided two apartments were a needless extravagance and found a seven-room flat in the 600 block of Fullerton Avenue. Deutch, Helene, baby Annick, Johanna and Julius and Gene all lived there.

Deutch still has a weathered copy of the original portfolio with which he made the rounds of Chicago's advertising agencies. Art directors praised the nudes, lyrical street shots and witty Paris ads gathered in the portfolio. They told Deutch to come back as soon as he had a studio. Warmed by their promises, he invested his $3,000 savings in equipment and a lease and opened Studio Deutch in February 1937 at 510 North Dearborn Street. He returned to the enthusiastic art directors but found them far more pragmatic and cautious on his second visits. Much of the advertising photography of the era followed a formula style of shadowless

precision and textbook detailing. Deutch's mood-laden lighting and stress on form, popular commercial approaches a generation later, departed too far from the 1930's norm.

Commercial jobs trickled in that first year. But Deutch survived because the monthly magazine *Coronet*, based in Chicago, bought a steady stream of his work. *Coronet*, published in a format that resembled a paperback book, devoted itself to commentary, literature and the visual arts with a portfolio of photographs in each issue. Deutch described his first visit there:

After a few months of futile efforts to get some business, get started, I went to see Coronet *magazine with a half a dozen prints. Eric Lundgren saw me, looked at the photographs. At the time I spoke very poor English and he always imitated my English. He said, 'Steve, you sit. I go see man. Pictures.' He took the six prints to the office of David Smart. Smart was the sole owner of* Esquire *magazine and* Coronet. *Eric came back. 'Boss likes. Good. How much?' I didn't know what to ask for and I said, 'Ten dollars all right?' 'Ten dollars. Six pictures. Sixty bucks. Not bad. You have more? Bring more!' I went back with another dozen prints. They bought them on the spot. I went back again and again. Without this man and his intuitive approach to my work, I don't know where I would be now.*

Thus Lundgren, a ruggedly handsome Scandinavian who was the art director for *Coronet*, became the

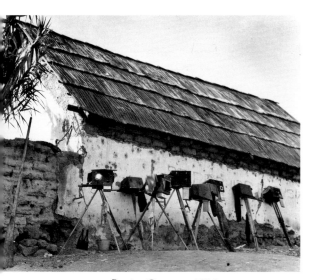

Resting Cameras, 1938
Mexico

Eric Lundgren, 1938
Chicago

first American editor to "discover" Deutch. Deutch's nudes and photographs of Paris scenes began to appear in *Coronet* late in 1937 and the prestige of the magazine helped pave the way for acceptance of his work.

Deutch and Helene traveled to Mexico with Gene in a broken-down Studebaker early in 1938 (Plates 14 through 16). They each took pictures and sold enough prints to *Coronet* and other publications to more than pay for the trip. The publication of these photographs further established their reputation as commercial photographers who were at heart artists. The Chicago Public Library exhibited their Mexico photographs in 1938 and the show traveled to Omaha, Toronto and other cities. Deutch's sculpture also began to receive recognition. The Art Institute of Chicago included two of his pieces in a 1938 group show. By then, however, their commercial business began to take off and Deutch had little time for sculpting.

The Studio

In 1938, Chicago illustrator Wendell Kling, owner of W. O. Kling & Associates at 75 East Wacker Drive, invited the Deutches to become the photographic arm of his art studio. Deutch moved to the 75 East Wacker building where his studio would remain a fixture of Chicago photography for forty-three years. "Kling's salesman sold us to the big agencies at a kind of money I wouldn't have dreamed of asking for," Deutch says. The salesman encouraged Deutch

to provide the art directors with the added perk of 16-by-20 or 20-by-24-inch enlargements of some of his nudes. Deutch provided the nudes. He drew the line, however, at wooing business with the standard three-martini lunch and casual conversation about sports and women. He found instead art directors who fell under the spell of his blunt candor as well as his creativity, and many of them became friends and associates whom he worked with for years. "He's like the First Mate Starbuck in *Moby-Dick*. The course of the ship could be set by his fidelity and his spirit," recalls Kassel. "I had this strong feeling both about him as a human being and his work. In a callous and hard business, he was a jewel." Abbott Laboratories hired him in 1938 to photograph a series of ads for which he created staged scenarios such as a businessman sipping coffee and reading a newspaper. Deutch drafted the building manager at 510 North Dearborn Street to pose for the picture. He posed himself for a photograph showing the textural skin of his hands against the textured vellum of an old prayer book for a Hammond Organ ad (Plate 21). He did vignettes as well for Eli Lilly (Plate 57), the First National Bank of Chicago and U.S. Gypsum. The pictures never show a product but suggest that the unseen product or service is part of the foundation of everyday life.

Many photographers were doing vignettes. What made Deutch's stand out was the unstudied spontaneity

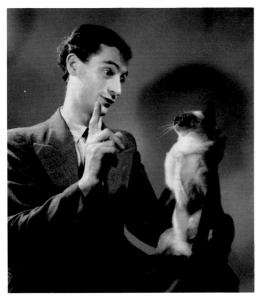

Stephen Deutch with Muki, 1933
Paris

he coached from amateur and professional models in believable environments. He delivered an advertising message with a documentary style several decades before anyone coined the word "docudrama" for staged reenactments of real-life situations. Like fiction, the photographs suggest a truer-than-life composite of reality. Such is the case in a powerful picture made for U.S. Gypsum that shows two men presumably fleeing the scene of a crime, pursued only by their long, jackknife shadows cast on a crumbling brick pavement (Plate 58). Deutch photographed them from above the street in the late afternoon, generating forms and a mood that are equally electric.

When he showed products, Deutch interpreted them lyrically. A simple cardboard box, unfolded and slashed by the shadow of another upright box, presents an enigmatic icon (Plate 23). A configuration of empty glass bottles, dramatically highlighted, throws off luminous, vertical bolts of light (Plate 22). He treated assignments to photograph inside production plants much as he did his street and travel photography, interweaving workers and the behemoth mechanical genies they controlled. As time went on, he would encourage corporate executives to leave their offices to pose for their portraits in the work environment as well.

Clients sometimes went to great lengths to meet Deutch's standards for environments. Container Corporation of America asked him to illustrate their 1964 annual report with pictures showing the multinational character of their company, which had plants in seven countries. He recommended profiling a working-class family in each country against settings that typified their culture. The company accepted the proposal on the spot. Such scenes, while posed, were strictly documentary in nature.

Environment became a hallmark of Deutch's fashion photography as well. Fashion photography for clients such as Marshall Field's, Carson Pirie Scott and Evans Furs grew to the point where it represented about eighty percent of his commercial business by the late 1940's. Deutch saw powerful patterns in the seemingly pedestrian environments he chose for on-location fashion photographs. The curved furrows of seats at an empty sports stadium, for instance, gave haute couture the added impact of a backdrop that appears tantalizingly abstract (Plate 35).

Betty Stearns, a fashion publicist for whom Deutch shot photographs for many years, describes his fashion work as dramatic yet reflective. "The strong sense of individuality of the model as a woman—that's what struck me about his work. He liked models whose bodies were structurally interesting. They were tall, unusual, almost Garboesque with a kind of inscrutable, deep sexuality." Deutch met one additional standard duty as a prominent Chicago fashion photographer—he judged countless beauty contests.

Stephen Deutch, age thirty-five
Photograph by Helene Deutch

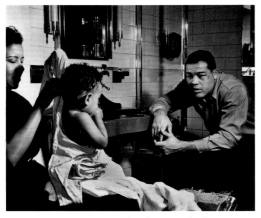

Joe Louis and wife Marva bathing
their son, 1949
Chicago

Besides applying an exacting artistic measure to his work, Deutch answered to a restless social conscience. He began volunteering services to various organizations in politics, the arts and social services almost as soon as his studio had a camera in place. Photographs taken for the Infant Welfare Society gave a direct and poignant documentary view of the mothers and children served by the society (Plate 107). The photographs convey need and dignity and stress, as do so many of Deutch's documentary pictures, fundamentals of life that enjoin all races and classes. In contributing to the war effort during World War II, Deutch photographed the home front for organizations such as the Community Fund. For an editorial assignment, he made a witty series of photographs that maintained the proper tone of patriotism while still capturing all the absurdities and indignities as the army processed new recruits through Fort Sheridan, twenty-five miles north of Chicago. *Hygeia*, an American Medical Association magazine, published the Fort Sheridan pictures.

Deutch free-lanced for countless magazines in addition to running the studio. *Ebony* published several memorable photo essays and portraits he did profiling celebrities such as Lena Horne, Joe Louis and Duke Ellington in the 1940's. Former *Ebony* editor Ben Burns noted in *Pista* how Deutch could get them "to really loosen up in front of a camera." The celebrity photographs quickly transcend the public persona.

Pictures of Horne in a Chicago hotel room suggest the isolation beyond the glitter (Plate 72). Photographs of Louis outside the ring reveal him fighting to maintain family life and financial control. One photograph shows Louis at the head of a table of business associates, their faces reflected as grim alter egos in the polished tabletop (Plate 76). Another shows Louis supervising his young son's bath. *Ebony* used a straightforward shot of the proud father and playful toddler from this group of pictures. They bypassed the sadder and emotionally complex photograph of the fighter, his scarred features obvious, gazing in wonder at his child's perfect profile. *Ebony* gave Deutch full freedom of the imagination for a series of photographs that illustrated an article on fantasies. He montaged exposures to create atmospheric dreamscapes that illustrated longings such as to walk nude downtown (Plate 78). Assignments for other publications brought him into contact with newsmakers as varied as University of Chicago physicist Enrico Fermi, former Chicago Mayor Richard J. Daley and baseball hero Jackie Robinson.

Deutch continued to make nudes in Chicago. He took some coquettish calendar girl poses but never strayed far from the coolly sculptural though far more sensual interpretation of nudity as an expression of poetic and beautiful forms. Though the work was classic in the extreme, one of the city's watchdog groups chose to view Deutch's nudes as corrupting public morals. The Legion

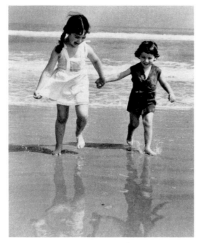

Annick (age five) and Kathy (age two), 1941
Photograph by Helene Deutch
Sawyer, Michigan

of Decency in Chicago filed a complaint against him in April 1939 and police came to the studio with a search warrant. They took away piles of prints and arrested Deutch. "The police came to our apartment and they said, 'Don't worry, don't worry. Nothing has happened.' Then they told me Steve was arrested. I had to bail him out. It was one hundred dollars and the policeman was very nice. He drove me to the station," Helene recalls. The Art Institute, magazine editors and advertising agencies joined forces to defend him and the charge was dismissed.

The studio itself sprawled across 2,000 square feet and included two darkrooms, a dressing room and reception and office areas, though Deutch moved to smaller quarters in the building in later years. The area for taking pictures had tungsten lighting and 4-by-5-, 5-by-7-, and 8-by-10-inch Deardorff view cameras in addition to several smaller-format cameras.

But despite success, Deutch never got over the hardships of his early life and remained always frugal "except where we were concerned," Kathy says. She recalls how he measured out the darkroom chemicals on antiquated scales and reused backdrop paper. Later, as a photographic stylist in New York, she watched photographers rip off skeins of backdrop paper, thinking how her father would have saved it. His equipment took on a vintage patina of wear and tear and tape over the years, but Deutch moved like a dancer amid it. "He'd drop a lens and stick

out his foot and catch it on his shoe," Kassel says.

The Closely Bonded Family

Deutch and Helene continued to work together in the early years of the Chicago studio, and they were a novelty in advertising circles. Frequently, they bickered over the set-up for a shot. At such times, the client smiled, waited for the smoke to clear and later walked off with additional photographs and better layouts at no additional charge as a result of the clash.

Johanna cared for Annick at first. Helene's mother joined them by the time Kathy was born in 1938 and she, Deutch, Helene and the two girls moved to their own apartment on Oakdale Street near Sheridan Road. Helene began working part-time after Kathy's birth and left the business completely in 1943. "We had little problems because as he said, there are no two captains in one ship, one has to be the boss. Well, at that point, I had had enough photography and I expected my third child and I said, 'All right, you be the captain. I retire.' And I really enjoyed being a mother finally. I was thirty-five years old at that time and I never cooked, I never made a dress for my children, I never did anything that a mother would do. So finally I became a full-time mother and I loved every minute of it."

Annick, Kathy and Carole remember the studio at 75 East Wacker as

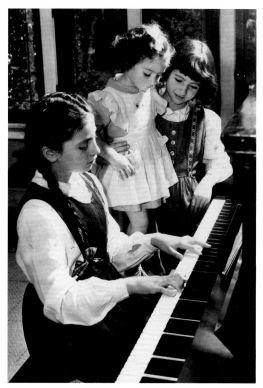

Annick (age nine), Kathy (age seven)
and Carole (age two) at the piano, 1945
Photograph by Helene Deutch

a place of infinite glamor and mystery. "We got to meet the famous people—that was part of the deal," Annick recalls. "Duke Ellington kissed Kathy and I on the cheek. We hung around and talked to the art directors. Sometimes we were included in the jobs." Streetwise schoolgirls attending the Francis W. Parker School, Annick and Kathy would take a bus downtown to music and dance lessons and then walk to the studio for an indoor picnic of sausage, cheese and bread.

Each daughter found special niches of interests to share with Deutch. Everyone considered Annick the family intellectual, but she was the one who listened to baseball games with him after an assignment to photograph the Cubs sparked his interest in the game. "I thought of myself as my father's son," Annick says. Kathy, an avid dance student and always interested in performing, liked working with him as a model when the opportunity arose. Carole, active in radical politics during the 1960's, found him a sympathetic supporter of her social causes but challenged his political views in intense debates. By then, Deutch was disenchanted with politics but not social reform.

Despite long hours at the studio, Deutch, Helene and their daughters played and traveled together. The sisters remember everyone gathering on the back porch of their Chicago apartment in the 1940's to listen to "The Lone Ranger" on radio. They grew peas and radishes for their victory garden in the small yard behind the apartment building during World War II when Deutch was the street's air-raid warden. They describe a home life filled with music. "I can remember lying on the floor with my father and both of us humming along to an opera or Beethoven and waving our arms, conducting the orchestra," Annick says. Deutch whistled classical songs and Kathy recorded the soothing melancholy of the strains as part of the soundtrack for *Pista*. He also took piano lessons, like his daughters, though he despaired of any real gift for playing. The whole family would set a stage and dance and leap their way through recordings such as *Peter and the Wolf*, Annick, Kathy, Carole, Helene and Deutch each taking different parts.

Family jaunts covered museums, ballets, concerts, plays and Chicago nightspots to hear blues or folk music. But the parents took the girls to the stockyards and factories to see how things were made as well. Vacations across America and into Europe were always family vacations with frequent stops where Helene and Deutch would pull out the cameras. "We always talked about light. In all our travels, light was of the essence. It's something so powerful within us. The play of light on people, on things, that was always his focus, his poetry," Kathy says. "When you're traveling, everything is new. We were drawn to try and see what he was seeing," Annick says. "He was bold. He would go into a street and start photographing people. But he was friendly and humble and he would try to connect with them." Not all their stops were

on the tourist maps. They viewed with shock the sharecroppers' cabins in Mississippi. They followed logging trucks out West and then stopped to see how the logs were tooled and finished.

The family moved to a rambling house in the affluent suburb of Wilmette in 1950. But a rustic summer home in Sawyer, Michigan, that overlooks Lake Michigan from a forested crest of the dunes, was the real family home. "Sawyer is the glue to our lives as far as a place," Carole says. The grandchildren as well as the children spent time growing up there and the whole hot-tempered, loving Deutch clan still gathers there. "I was separated. Kathy was separated and then her husband died. Annick's husband had died. We were all looping around our father and mother with our children and they roped us all back together again," says Carole.

The daughters took circuitous paths to filmmaking that roped the family together in an artistic sense as well. Annick worked as an editor at the University of Washington Press while her husband David Smith, a lawyer, worked and returned to school to earn a doctorate degree in English literature. They turned to filmmaking together and made a documentary about poet Richard Hugo before Smith died in 1974 after a long illness. Annick went it alone, produced several films about Native Americans, and in 1979 produced *Heartland*, a critically acclaimed feature film. She recently coedited an anthology of Montana literature called *The Last Best Place* and made

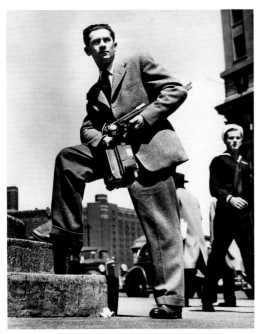

Stephen Deutch in testimonial advertisement for Quick Set Tripod, c. 1940
Photograph by studio assistant

a video based on historic people in Montana, her adopted state, where she lives on a ranch.

Kathy, who lives in Massachusetts, worked as a model, actress and photographer before beginning to write, direct and produce films in the 1970's. Her current film projects include a feature drama, *Dignity*, based on the life of the leader of a union for the homeless and a documentary, *Nelson Algren: Who Lost an American Writer?* Carole, her former husband Peter Wiley and Peter's brother Brad, cofounded *Leviathan*, a radical political publication which they published through 1971. She lives in San Francisco, where she worked with citywide programs and directed a community center until 1980. She now makes corporate films and commercials and has worked on documentaries.

Of the sisters, Kathy has most publicly chronicled her family and her father's career and she eloquently described each of her parents in "Sisters: As Big as the Sky," an essay that she presented at the 1987 Women's Caucus for Art in Boston.

Not content with being a master woodcarver, sculptor and photographer, Dad was determined to make up for the formal education he never had. He drove himself to learn—about everything—and passed it all on to us. He was handsome, sexy, athletic and traded on his machismo, but never made us feel inferior or exploited. He was kind, honest and excessively generous to others, while monkishly sparing of himself. He was, and still

is, dedicated to protecting and supporting his family and to an impossible personal, political and artistic standard. Though embittered by a world he could not change and would not exploit, he is humbly proud of his contributions.

Mom had the education that Dad always wanted. She taught him photography, bolstered his confidence, and after a time, stepped aside. If she was jealous of his notoriety, his adoring fans, his glamorous models, she hid it. Her love for Dad was total. Her love for her children was consuming. She encouraged our father- worship, but challenged Dad herself, guided not as much by fact and logic as by instinct and determination. She was as sure of herself as Dad was questioning. The rigid concept of beauty and excellence she imposed on us is surpassed only by the joie de vivre she has instilled in us. Her twinkling eye, powerful stride and gutsy laugh burst through her tiny frame, signaling a toughness and resilience, rare in a woman of her time, or any time.

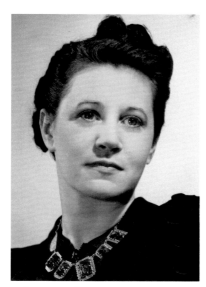

Helene Deutch, 1938

The Crisis

The travel, the lessons, the private school in Chicago and the move to Wilmette all reflected Deutch's financial success. That success enabled him to support his parents, his mother-in-law and help relatives still in Europe. The well-being of so many secured by that success made it palatable. "There was a philosophy that if you didn't do what you wanted to do, namely in my case become a sculptor, but you were good enough in what you were doing to make the money, then convert that earned money into enriching your life. That meant we were able to go to concerts and theaters. We took the trips with our children, always with our children," Deutch says.

But success by all the pragmatic and worldly measures couldn't quell his sense of inner conflict concerning his commercial career and his art. Proud and self-appraising, Deutch cuts himself few breaks in any arenas of his life. Though his political interests have faded, he still broods more than fifty years later for not joining the Republican forces aimed at stopping Francisco Franco's fascist power grab during the Spanish Civil War in 1936. "I felt I should go and I was torn between obligations to my child and wife and the risk of going. I didn't go. I came to America. It was a cop-out. I took comfort and security in favor of political conviction," he says.

In America, he followed convictions in support of a fairer social order by joining the Communist Party. There, political idealism quickly butted against the authoritarian reality of the party leadership. Deutch soon left the party and turned instead to the labor movement and other progressive causes as a force for achieving social reform.

Deutch's deeply-rooted passion for life comes through vividly in his street photography. The pictures convey the sense of an inward as well as an outward search and the very making of such pictures reflected Deutch's festering inner

conflict between success as a commercial photographer and longing for artistic expression.

Finally, with Annick married, Kathy studying abroad and Carole a junior at New Trier Township High School in Winnetka, Deutch asked Helene for a divorce. He married again from 1960 to 1965 and did some sculpting but remained lonely without Helene and increasingly guilt-ridden over their divorce. He maintained the studio and his commercial clients but turned with greater fervor to street photography to fill some of the aching spaces in his life.

Deutch had started exploring Chicago in 1938 when an assignment to photograph the city's public schools brought him into contact with its pastiche of neighborhood life. Chicago streets and Chicago stories became a natural bond between him and writer Nelson Algren when a publisher needed a new Algren portrait and introduced them in 1960. Algren loved to be photographed and loved to suggest photographs such as one Deutch took with Algren at his elbow of a homeless man in an urban cocoon where a cement wall flanks a gangway (Plate 118). "We would drive around and he would tell story after story about Chicago," Deutch says. "He loved to tell stories. He could just tell stories for hours without stopping. He paces up and down the room and imitates gestures or movements of the character in his story, having a lot of fun, laughing at his own jokes. Nobody else did sometimes."

Algren, without a family of his own, adopted the Deutch family, especially after Deutch and Helene remarried in 1965. He came to Sawyer a few times, a quirky house guest who never differentiated between night and day and never seemed aware that anyone else did. Deutch worried about Algren and let him laugh at the idea of someone worrying about him. They both knew the caring was mutual. But Deutch says his only real explanation for their close friendship was their regard for the decency each saw in the other. "I was as surprised as anyone in this town when I found out he dedicated his last book to me," Deutch says. The book was *The Devil's Stocking* and Deutch learned of the dedication one week after his friend had died in 1981.

The summer after Algren's death, his friends held a memorial service for him at Second City. It was more of an Algren-style party, complete with a blues piano player. "I never thought that Nelson was a simple person to know. I thought he was a complicated person indeed. And it made it more difficult to know him because I thought he always wore a mask. He liked to project images of himself to all of us and not necessarily the same [ones]," Deutch said in his eulogy at the memorial service. "You had to see Nelson's eyes, those malicious, mischievous eyes. They said more sometimes than the words in his stories. And through that, sometimes, you got a bit of a glimpse of the real Nelson Algren somewhere in the back."

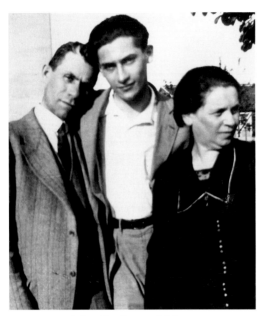

Julius, Stephen and Johanna Deutch, 1935
Paris

Helene Deutch (foreground) with
friend, 1936
Paris

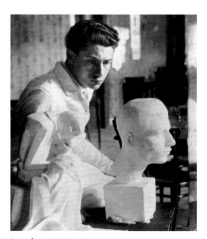

Stephen Deutch, age sixteen,
with sculpted self-portrait
Budapest

Three Documentaries

In the 1950's and 1960's, Deutch took the photographs for "Bench Sitters" and "Doors and Windows," two compelling documentaries. A third documentary, "Twilight World," exposed the plight of patients in Chicago mental hospitals and won him the nomination for the Pulitzer Prize. Deutch considers these projects his most significant work and with good reason

"Bench Sitters," exhibited in 1959 at the Chicago Public Library, struck at a public arena where the isolation of the individual amid many is all the more obvious. "Many of these people are lonely, very lonely, some of them without any ties," wrote Deutch in the exhibition label. "The benches of Chicago—made of stone, wood or iron—in the parks, on the avenues and streets provide these people with islands of refuge."

But Deutch also made apparent with light-hearted wit the visual parodies of urban life presented by the way people unconsciously command their benches. They sit in a row, all their legs crossed in the same direction like so many perching pigeons. On less crowded benches, they honor some unstated privacy convention dictating that each person take an end. Lovers, of course, glue together at the center of the bench. Two men lie head-to-head on two adjacent benches with their lunch boxes as pillows and resemble a twin pair of statues in one picture (Plate 95). In another, a lady wearing a print dress sits solidly on her folding chair fish-ing at the lakefront in no-nonsense tolerance of the streetwise young toughs looking on. Deutch managed to capture a cross-section of the city with "Bench Sitters," from Diversey Harbor to Garfield Park, from the chess pavilion at Lincoln Park to what was once "Hobo Square" on Clark Street.

Looking at photographs as art remained the province of a very confined audience in the 1960's. Stellar photographers such as Edward Steichen, Margaret Bourke-White and W. Eugene Smith published in the national picture magazines. But readers who religiously paged through the photographs of *Life* and *Look* every week over a cup of coffee would have been hard-pressed to name the photographers who took them. When Hugh Edwards, former photography curator at the Art Institute of Chicago, first saw a selection of pictures from Deutch's photographic series "Doors and Windows," he compared it to the work of Walker Evans and Robert Frank. Deutch, who followed his own instincts only in making the photographs, had to track down the work of each man before he realized Edwards was comparing him to "two gods in photography."

Like Evans, Deutch captured a social landscape in sketches of the commonplace that maintain a deeply resonant and narrative quality. Like Frank, he suggested the tattered edges and downbeat realities of the American dream. "Doors and Windows" often showed the frayed architectural detailing of buildings

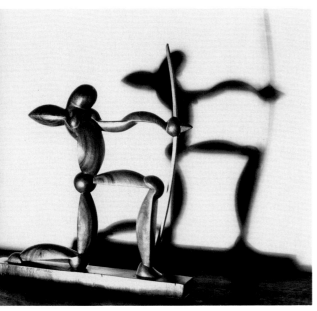

Archer, 1933-34
Wood sculpture, Paris

on streets recycled from upper-crust to middle-class to down-and-out. But the power of the pictures lay in their emotional charge, in their ability to convey with a door or window a sense of the mystery and pain of everyday life just beyond.

Deutch's perspective remained compassionate, though never sentimental. And while the view may be a gritty mirror to a city's raw wounds, Deutch never trivialized life, even on Skid Row. Sometimes the stance is humorous, as in one photograph of baby buggies parked outside a liquor store (Plate 89). It's impossible to tell whether the patrons who park them have brought the babies or merely the buggies as a handy and discreet shopping cart. Sometimes the scene is discomforting, as in one photograph where a transient sits with a bandaged nose and a resigned expression against a scarred, closed door. Two figures approach him but the viewer sees only their threatening shadows and the tip of one polished shoe that suggests the wearer is a cop. The viewer tenses for the man. Even the shadow of the streetlight on the doorway above his head seems ready to clobber him in his treacherous surroundings. It's difficult not to compare the picture to one taken some thirty years earlier in Paris where two clochards sit drinking against a wall, in serene contemplation of the passing world on the Seine.

Even at the doorways of dingy flats, the photographs pull the viewer with deep longing to the unreadable scenes on the other side of the windows and doors. One photograph shows a series of closely packed stairways to individual apartments, an elusive geometry of public and private space. Like so many pictures in "Doors and Windows," the boundaries dividing the viewer from a person seemingly just out-of-sight strike a forceful reminder of the solitary confinement of each human mind. "They become part of the pattern of the structures that frame them, surround them, blending into the cityscapes, they are part of the city," Deutch continued in the exhibition label for "Bench Sitters," written in the form of a poem. The description applies aptly to "Doors and Windows" as well. And indeed, much of Deutch's street photography suggests a ballad for modern times, but one told by a photographer rather than minstrels of ages long past.

The ballad turns into a silent scream, however, in the riveting and sobering series of photographs called "Twilight World" that ran in the *Chicago Daily News* for five consecutive days in March 1965. Don Kassel's wife Myrna, who worked for the state mental health department, asked Deutch to photograph at Chicago State Hospital for the mentally ill so the pictures could be used in a new admissions brochure. After the project, Deutch asked Kassel for clearance to continue photographing at Chicago State, Dixon State School for the retarded and Elgin State Hospital for the mentally ill. Deutch showed the photographs to Herman Kogan, a friend and editor at the *Daily News*, and the paper

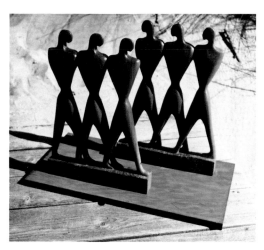

Egypt, 1989
Wood sculpture

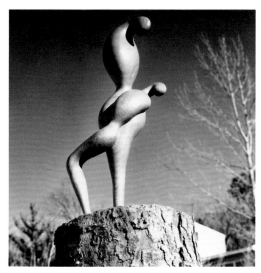

Pietas, 1989
Wood sculpture
Collection of Harry Petrakis

dispatched a reporter to research the story that accompanied the photographs. In one picture, a group of boys seek the refuge of a brick wall, two cowering against it, one facing it, one laying down beside it. In another, two women who are constant companions, clutch each other as if they are the only solid things in a swaying universe. In still another, a young woman poses with her eleven dolls tight in her arms and strung from her hair like modern-day totems.

Picture after picture pries the lid off all the polite refinements that mask human pain. The series drove home the inadequacy of staffing at the overcrowded mental hospitals and resulted in additional funding for mental health care in Illinois, though the hospitals since have been closed.

But the photographs draw their eloquent and haunting magnetisim from the fact that Deutch confronted his subjects (and enlists the viewer to confront them) not as different or deranged but very simply as human beings. With this potent bond of common humanity, Deutch gives a hundred faces to all of human vulnerability including his own. "The taking [of the pictures] was difficult because I couldn't separate my feelings from what I saw and what I thought I should do. I was overemotional about it. I couldn't sleep for nights. I was crying about it. I woke up in a sweat and smelled the urine in those big, common halls," he says. "I knew it then and I never lost that feeling that I finally made a contri-bution that is meaningful and worthwhile. If I don't do anything else at least I will have that on my record so Saint Peter will let me in."

After "Twilight World" ran, Deutch received dozens of letters but none as touching as the one quoted in part below that came from a downstate teacher of retarded children.

Dear Friend of the Retarded:
I am a teachers' aid at the Roosevelt School in East Peoria, Ill. I help the retarded. Our project is unfolding newspapers for Helen Gallagher's Gift Shop. Helping a retarded boy unfold his newspaper, I came across this paper, 'The Chicago Daily News, March 6, 1965.' I took it home and read it…. The picture of the boy in Dixon is most pitiful. But God made him, and He has made people who can touch his heart. I know the nurse is doing a beautiful job with him. Even if he refuses to eat, I know there is a little light which shines inside of him.

The photograph to which the teacher refers is one of a a girl, rather than a boy, according to the caption. She peers warily at the camera from behind a veteran nurse whose eyes filled with tears in empathy for her charges as she spoke to Deutch about them (Plate 97).

"Faces and Places"

Deutch and Helene began to travel around the world in 1965 after they remarried. Deutch had preferred black-and-white film on the road but for these trips to Africa, Japan,

India and Europe, he began to shoot exclusively in color. Deutch started working with color in the studio in the 1940's. But it wasn't until he made his later travel photographs that he began to understand color as an intrinsic element to the dynamics and composition of the picture. He switched cameras as well, turning in 1972 to a 35-millimeter from the 2 1/4-format camera he had always used on trips.

His universal themes and narrative photography remained constants, however. "I started to get interested in photographing the people of the world as I had photographed the people of Chicago," Deutch says. "We are all alike, and we are all different. That's what I found out. And if that was what comes through, that was all I was trying to do." Each picture tells a story. Pilgrims gather in a sacred city of India where the old and the ill come to die. An array of colorful umbrellas opened against the rain in Japan resembles a flower garden.

The power of form combines with the dignity of face and figure in the color travel photographs of the 1960's just as it did with Deutch's earlier black-and-white photographs from travels in Europe, Mexico and across the United States (Plates 136 through 143). But Deutch used color to emphasize the monochromatic infinity of a sandswept landscape or the impressionistic blur of pastels in a Paris garden. He had little trouble with language barriers. People saw the camera and understood. With utter poise and certainty of self, they stood their ground for a portrait or continued with their business as he snapped the shutter.

From a documentary standpoint, many of the pictures capture styles of living and working that shed several centuries in a single image. But hospitality maintained its old traditions as well. Helene distributed candy to a group of village children in Turkey. "Minutes later, a man with a beard and a big coat on came out with a melon and gave it to Helene. He saw Helene giving candy to the children and he reciprocated. That's what the photographs are all about," Deutch says. The Chicago Public Library Cultural Center showed the travel photographs in a 1981 exhibition called "Faces and Places," the library's third exhibition of his work. The library hosted a showing of *Pista* along with the exhibition. Portfolios of Deutch's work have appeared since in *TriQuarterly* magazine, *Chicago* magazine and Studs Terkel's 1985 book, *Chicago*.

Deutch moved his studio from 75 East Wacker Drive to 114 West Illinois Street in 1981 and remained in business there until 1983. He continued to do some fine commercial photography until 1986 but devoted more and more of his time to sculpture. At present, he and Helene split their week between the home in Sawyer, Michigan, where he has his sculpting studio and their high-rise apartment in Chicago. But now, with time to pursue his first love in art, arthritis has made the work very painful and slow. "I am a great admirer of his photographs but even more excited about his sculpture. It's full of emotion, very sensual and very free flowing," says Deutch's close friend, writer Harry Mark Petrakis.

The two met only a few years ago and so Petrakis is one of the few people who knows Deutch as a sculptor first and foremost. His home is within an hour's drive of Sawyer and they get together frequently. "Despite the arthritis, he works for months at a time, carving a tree trunk or hunk of wood. When you see that it's very moving. You sense a man who has lived fully," Petrakis says. "We walk the beach and discuss all the lofty and ponderous thoughts of life."

The Plates

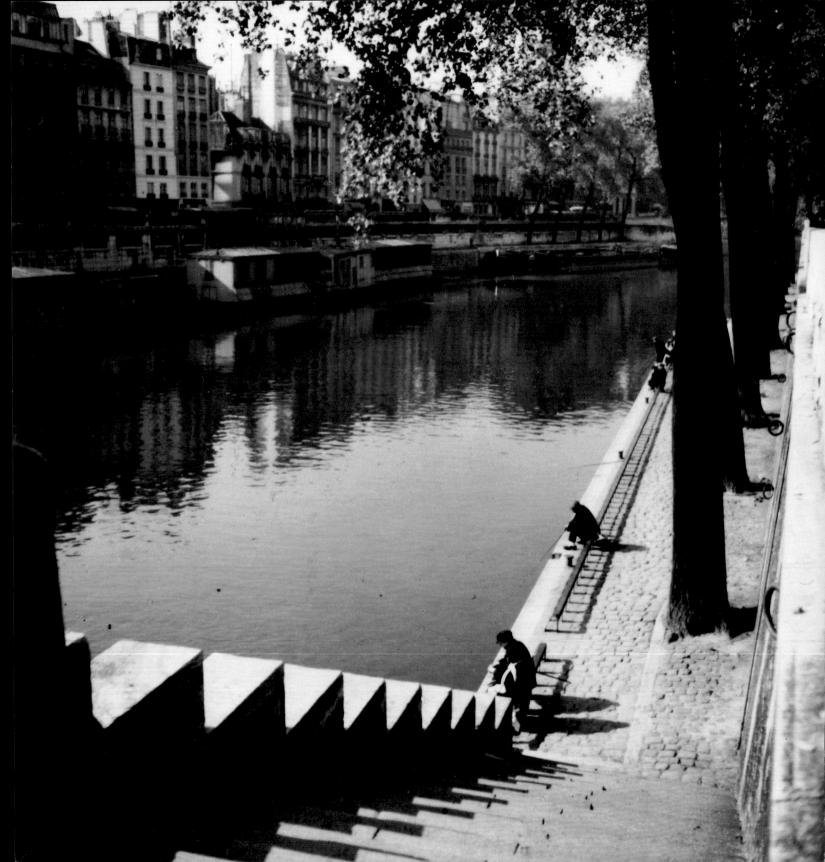

1 | *Oh Paris…*, c. 1934
The river Seine and the quays,
Paris

2 | *Aperitif on the Boulevard*, 1934
Paris

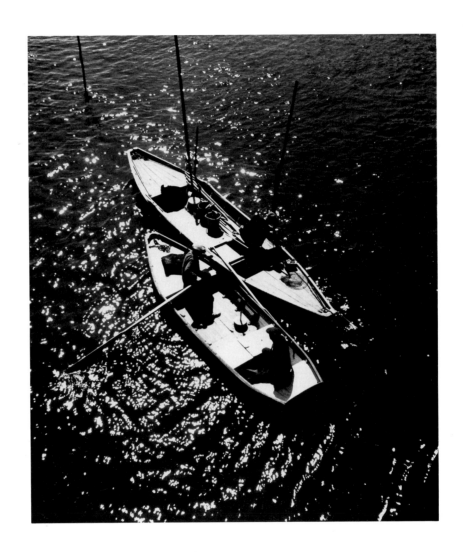

3 | *Fishing,* 1934
Paris

4 | *Coup de Rouge,* c. 1934
Clochard on the quay enjoying a drink,
Paris

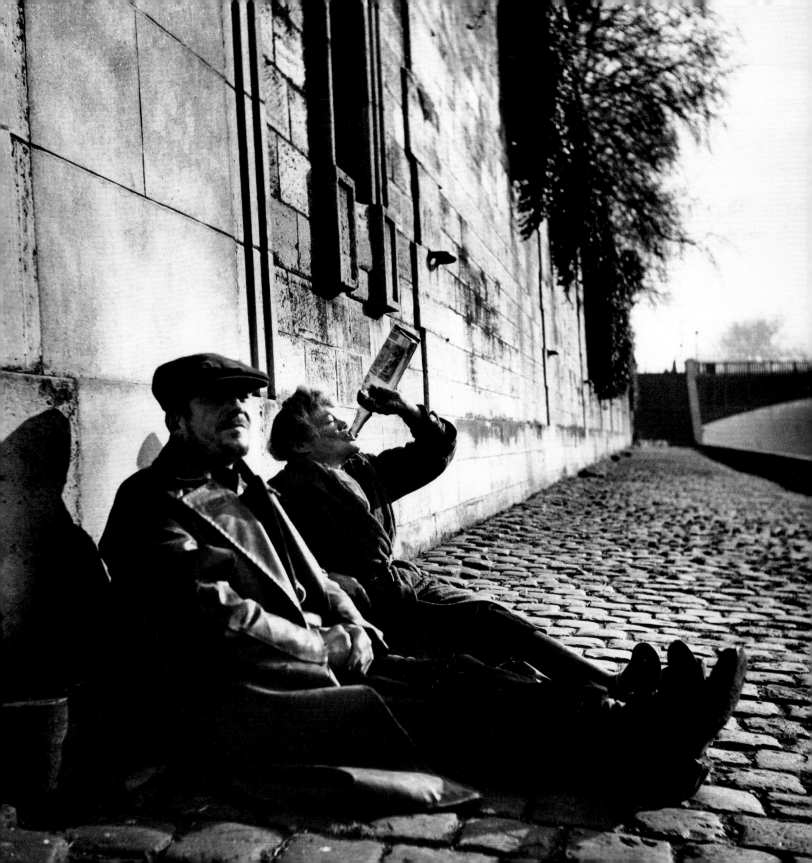

5 | Colonial woman, 1932
Photographed for a French advertising
agency, Paris

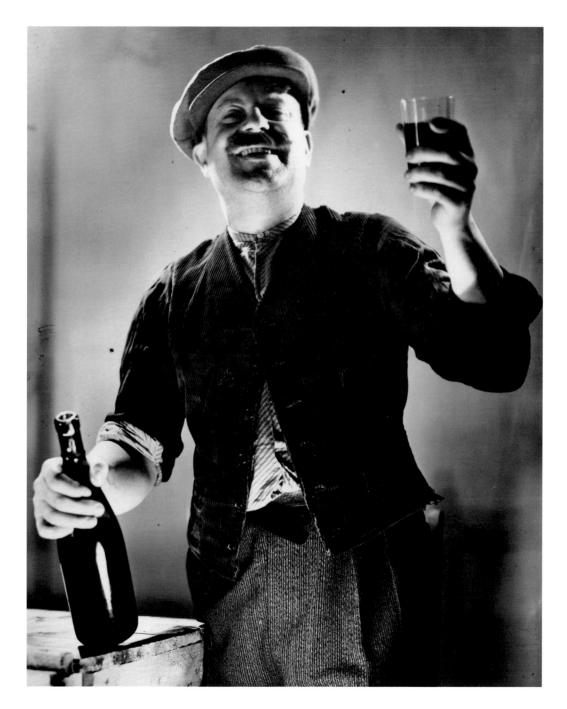

6 | *A la Votre*, 1932
Photographed for a French advertising
agency, Paris

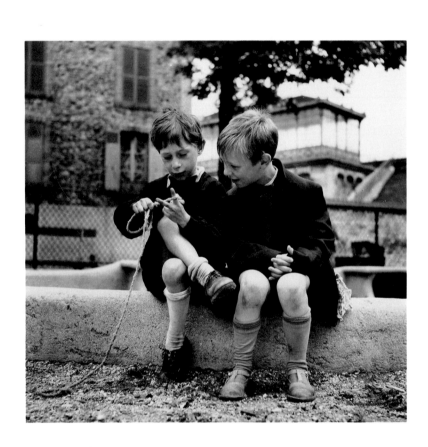

7 | *Two Boys,* 1934
Paris

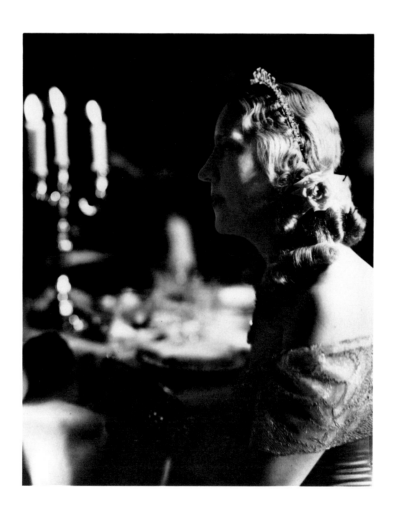

8 | *Pomp and Ceremony, the Grand Comedy*, 1934
At the Phillippe de Rothschild home, Paris

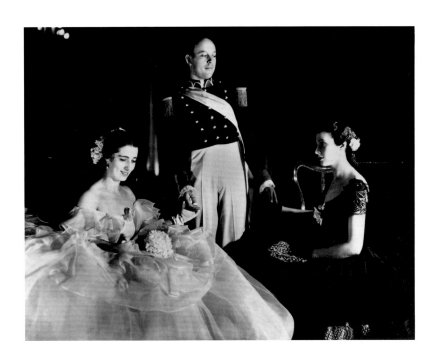

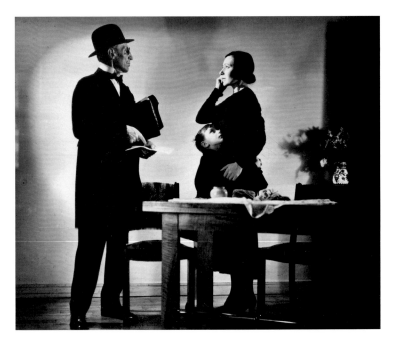

9 | *Gala Event*, 1934
At the Phillippe de Rothschild home,
Paris

10 | Widow confronting collector, 1934
Photographed for a French insurance
agency, Paris

11 | *Porthole*, 1936
Atlantic Ocean

12 | New Mexico, c. 1940 13 | Reservation pueblo, c. 1940
 New Mexico

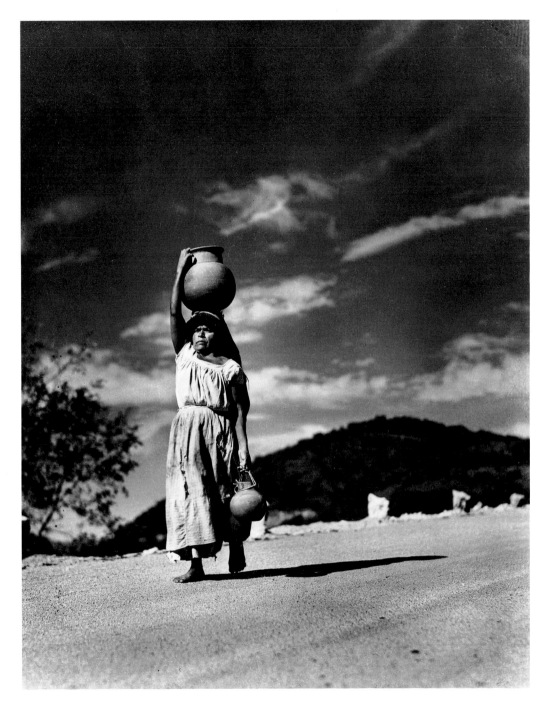

14 | *The Noble Carrier,* 1938
| Mexico

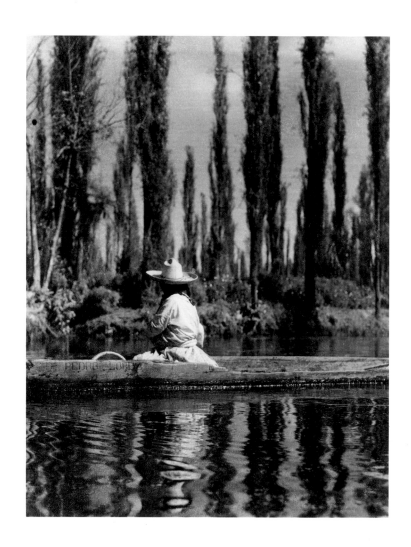

15 | Chapultepec Park, 1938
Mexico

16 | Harvesting cactus fluids
to make tequila, 1938
Mexico

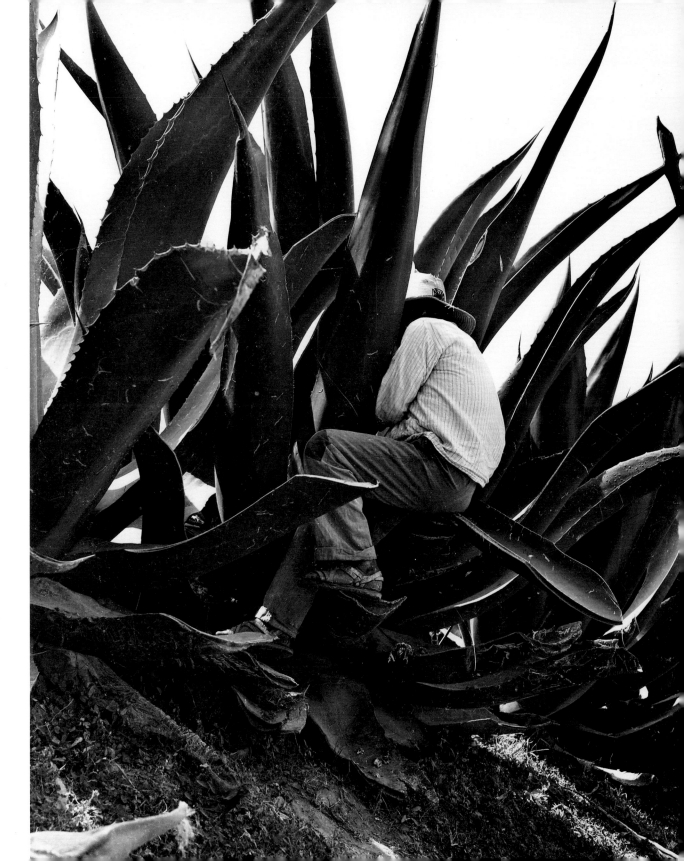

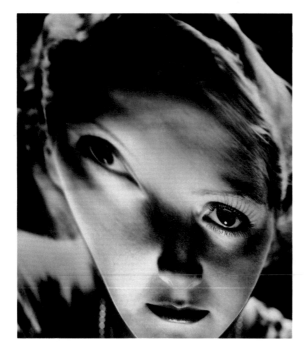

17 | *Untitled*, c. 1950
Experimental photograph using bent
paper, Paris

18 | *Ghost*, c. 1960
Experimental photograph, Chicago

19 | Advertisement with paper cut-outs,
c. 1960
Photographed for Master Line, Chicago

20 | Advertisement for games and toys,
c. 1945
Client unknown, Chicago

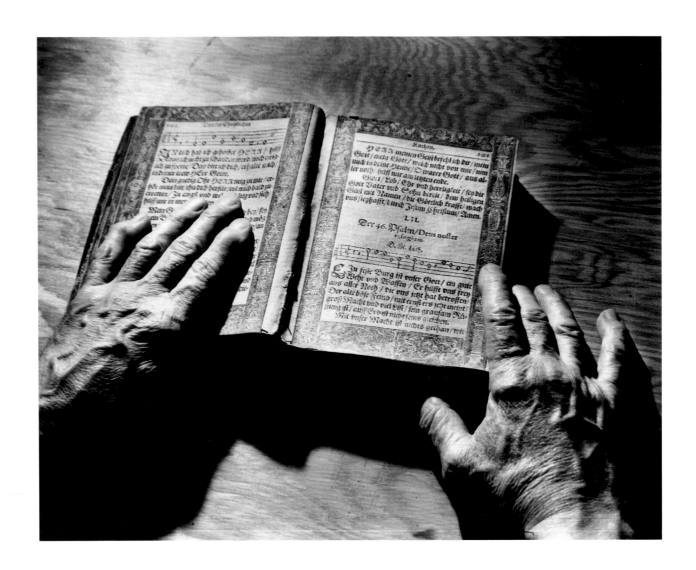

21 | Prayer book with hands for Hammond
Organ Co. advertisement, c. 1955
Photographed for Young and Rubicam,
Chicago

22 | Packaging advertisement, c. 1970
Photographed for Container
Corporation of America, Chicago

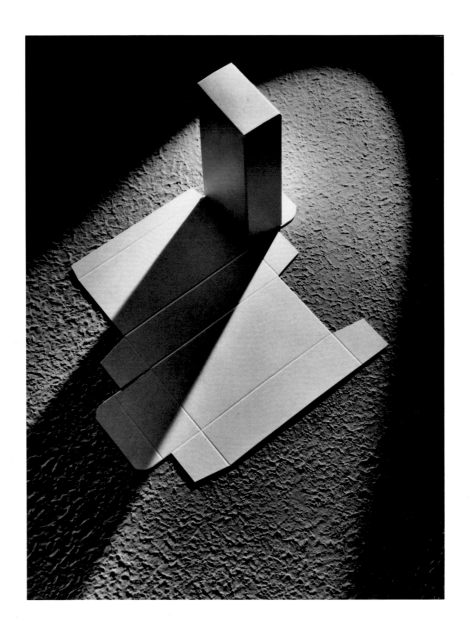

23 | Packaging advertisement, c. 1955
Photographed for Container
Corporation of America, Chicago

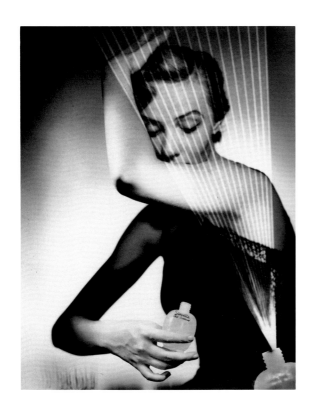

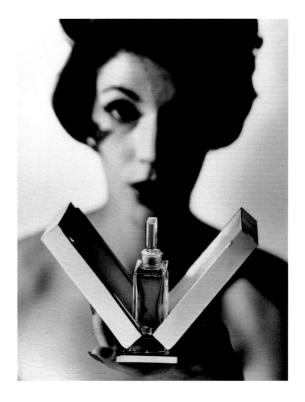

24 | Deodorant advertisement, c. 1955
Client unknown, Chicago

25 | Cosmetics advertisement, c. 1965
Photographed for Marshall Field's,
Chicago

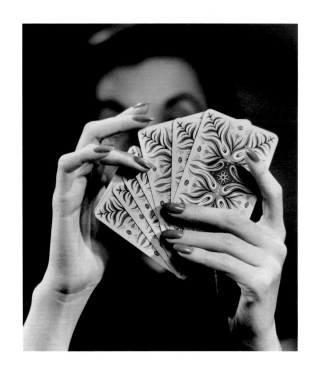

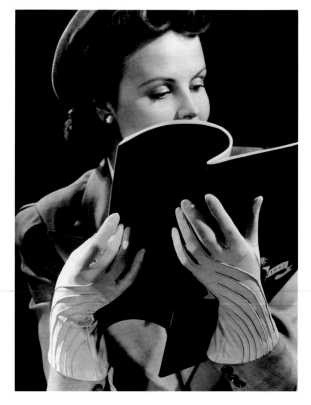

26 | Product advertisement, c. 1955
 | Photographed for Marshall Field's,
 | Chicago

27 | Gloves advertisement, c. 1945
 | Photographed for Marshall Field's,
 | Chicago

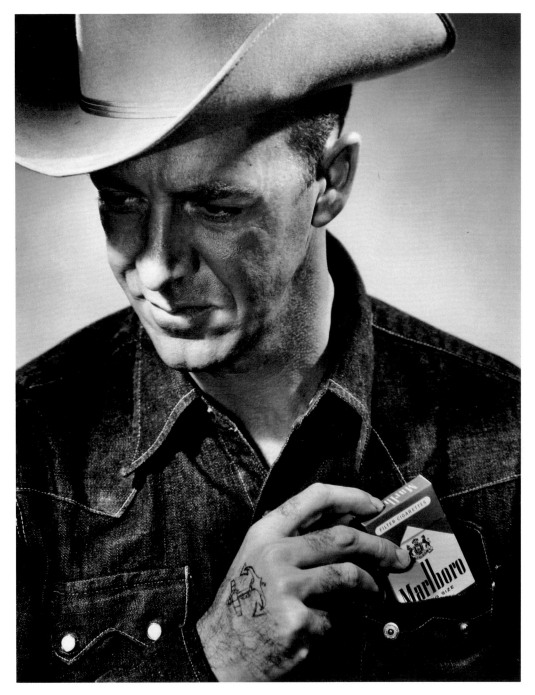

28 | Marlboro man, c. 1960
Photographed for Leo Burnett Co.,
Chicago

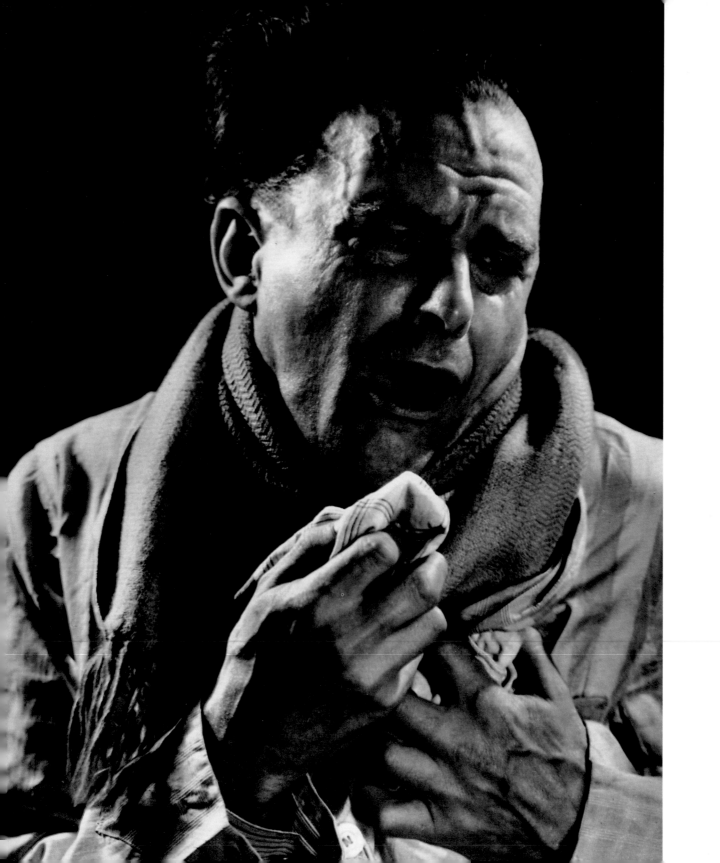

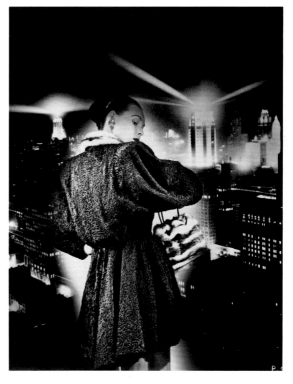

29 | Cough medicine advertisement, c. 1945
Client unknown, Chicago

30 | Fashion advertisement, c. 1950
Photographed for Marshall Field's,
Chicago

31 | Fur-coat advertisement, c. 1950
Photographed for Evans Furs, Chicago

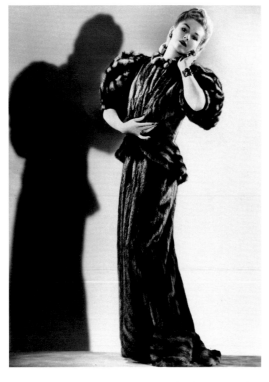

32 | Fur-coat advertisement, c. 1950
Client unknown, Chicago

33 | Men's fashion advertisement, c. 1950
Photographed for Marshall Field's,
Chicago

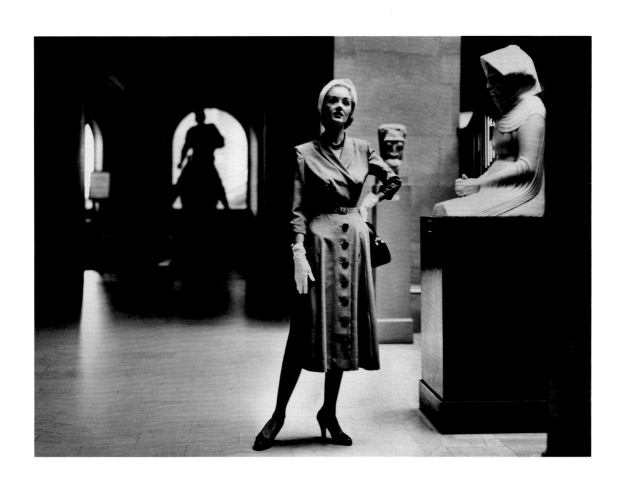

34 | Women's fashion advertisement, c. 1950
The Art Institute of Chicago,
Photographed for Marshall Field's,
Chicago

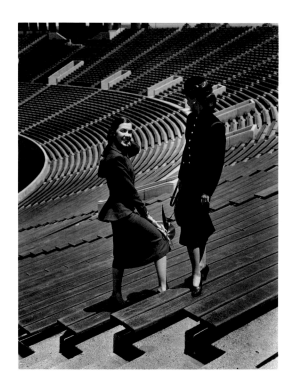

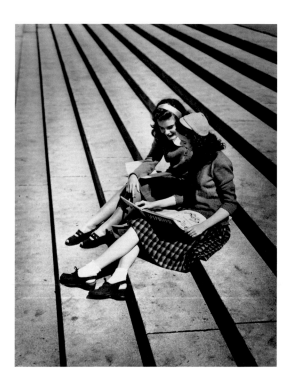

35 | Women's fashion advertisement, c. 1955
Originally appeared in *Mademoiselle*
Soldier Field, Chicago

36 | Front steps of the Field Museum of
Natural History, c. 1958
Photographed for a shoe company,
Chicago

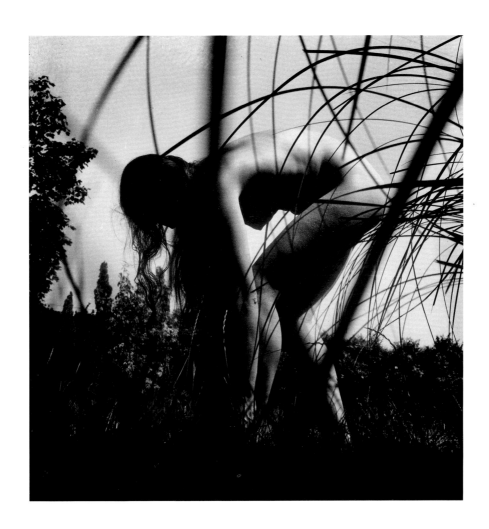

37 | *Nude Outdoors* by Helene Deutch,
c. 1934, France

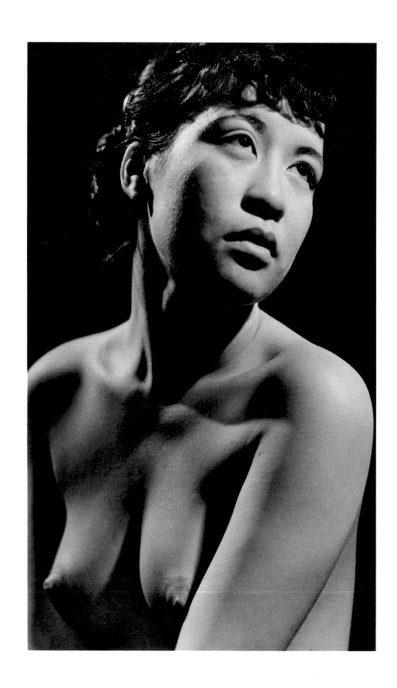

38 | *Nude Study,* c. 1950
Chicago

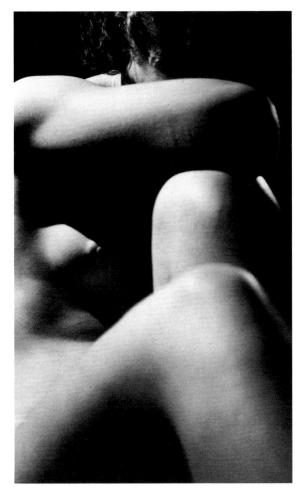

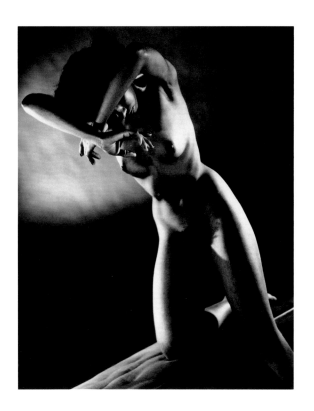

39 | *Nude Study*, c. 1950
Chicago

40 | *Nude*, c. 1950
Chicago

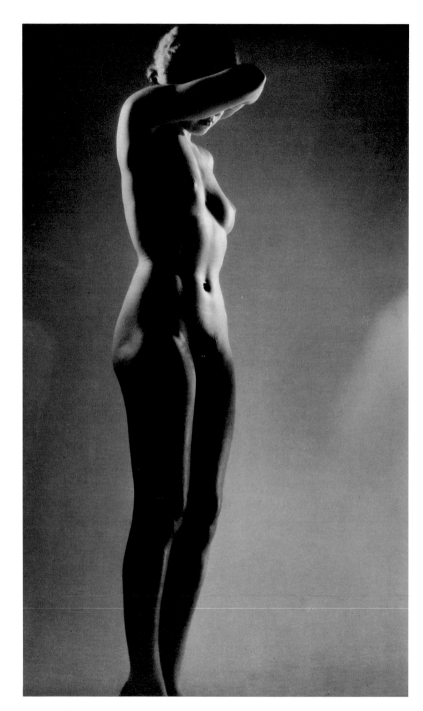

41 | *Nude Study*, c. 1950
Chicago

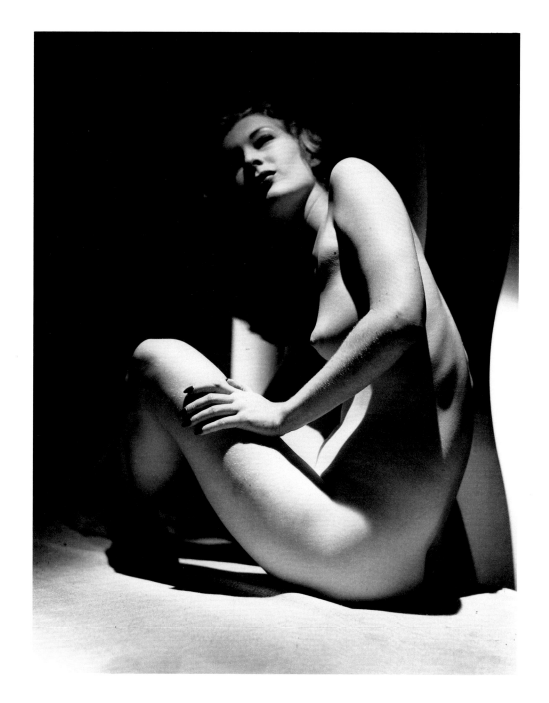

42 | *Nude Study*, c. 1940
Chicago

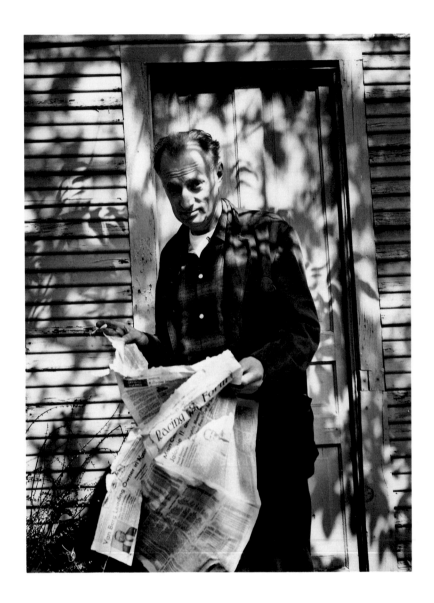

43 | Nelson Algren, 1962
Chicago

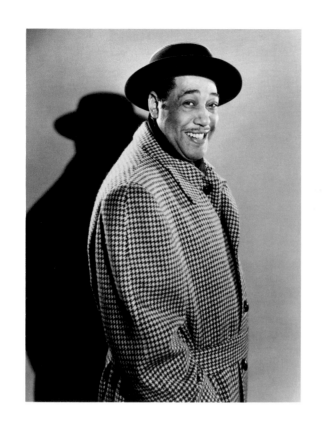

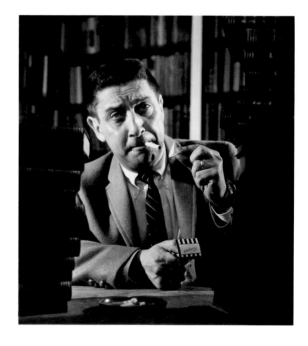

44 | Duke Ellington, c. 1950
Chicago

45 | Sidney Harris, c. 1960
Chicago

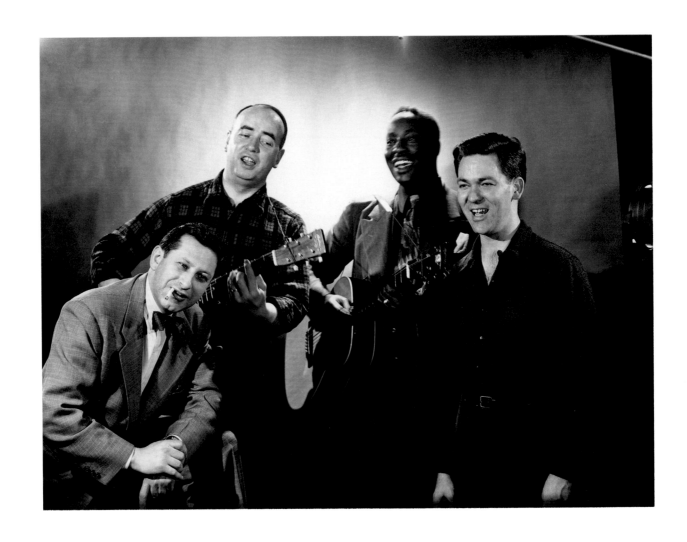

46 | *People's Song* (Studs Terkel,
Win Stracke, Big Bill Broonzy and
Larry Lane), c. 1940
| Chicago

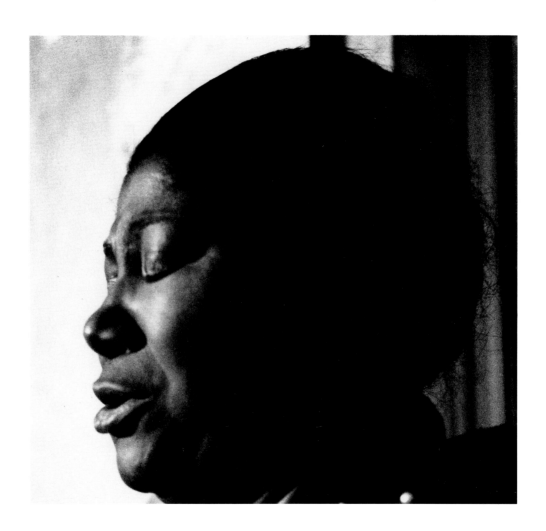

47 | Mahalia Jackson, c. 1960
Chicago

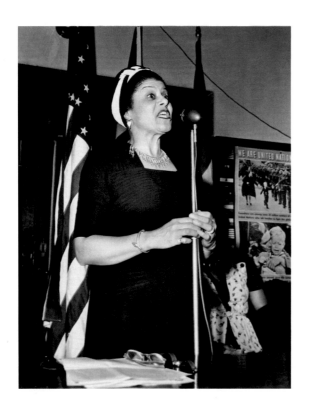

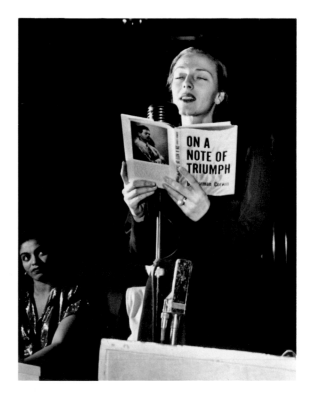

48 | Political meeting, c. 1950
Chicago

49 | Political meeting, c. 1950
Chicago

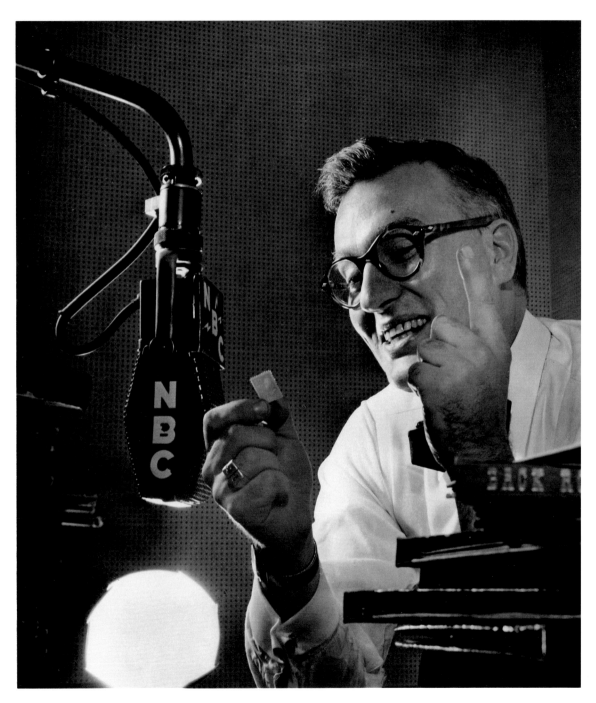

50 | Dave Garroway, c. 1940
Photographed for NBC,
Chicago

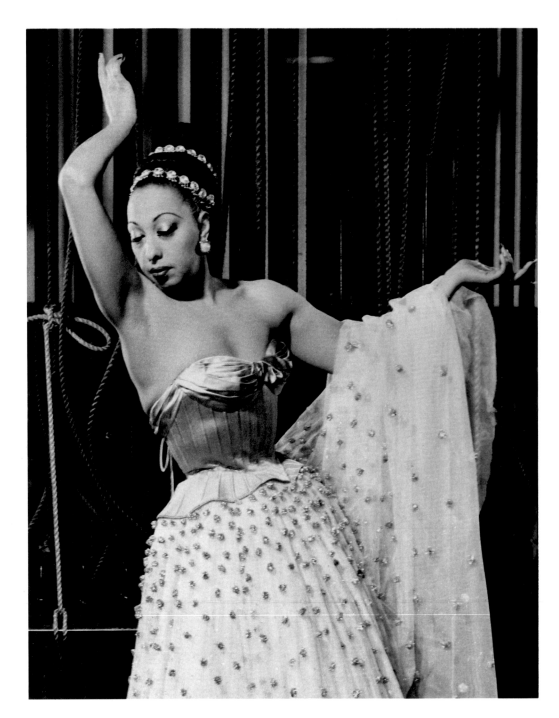

51 | Josephine Baker, c. 1950
Chicago

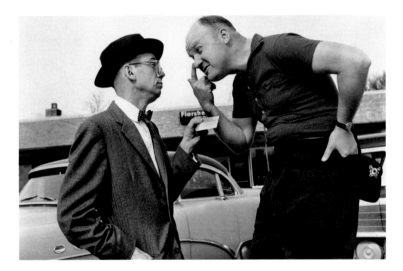

52 | Proof sheet, c. 1960
Photographed for Young and Rubicam,
Chicago

53 | Staged scene with models, c. 1960
Photographed for Young and Rubicam,
Chicago

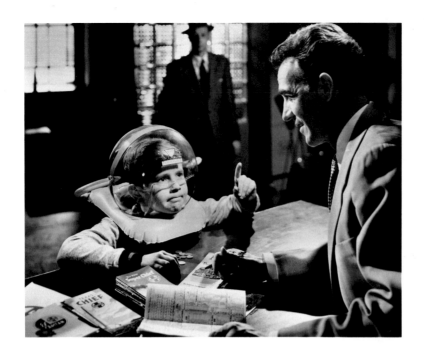

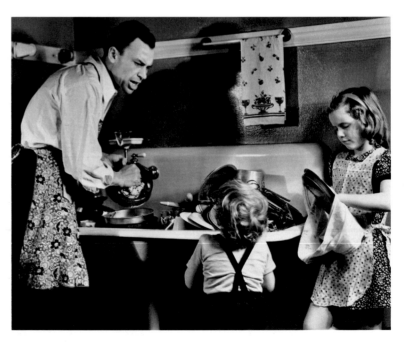

54 | Staged scene for Santa Fe
advertisement, c. 1950
Photographed for Leo Burnett Co.,
Chicago

55 | Staged scene with models, c. 1940
Photographed for U.S. Gypsum,
Chicago

56 | Staged scene for community
fund advertisement, c. 1940
Photographed for Community Fund,
Chicago

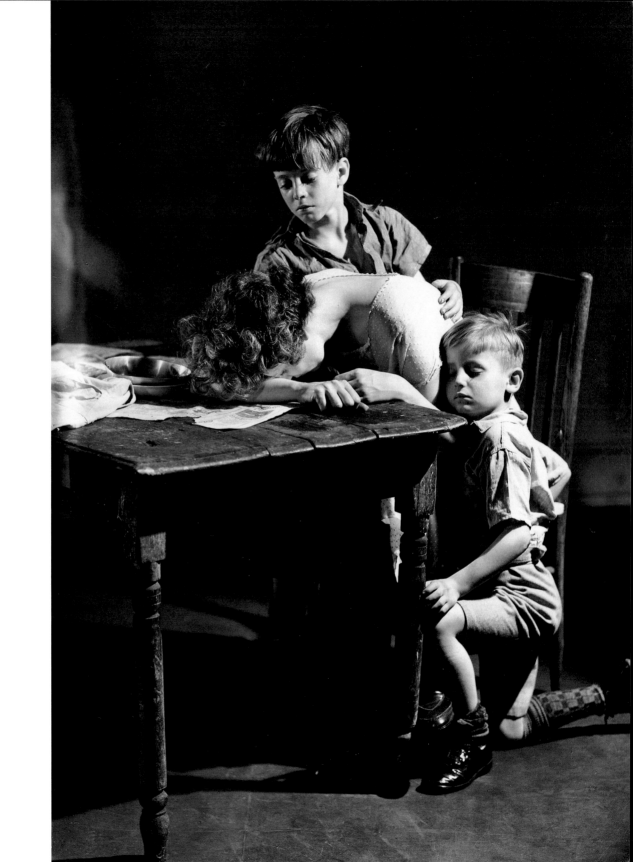

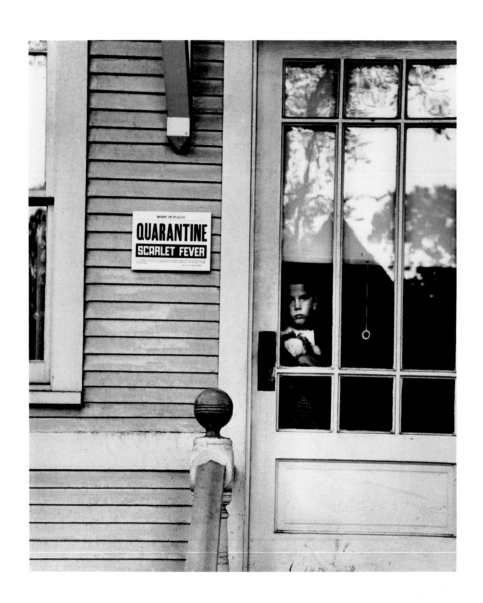

57 | *Quarantine*, c. 1950
Photographed for Eli Lilly advertisement,
Evanston, Illinois

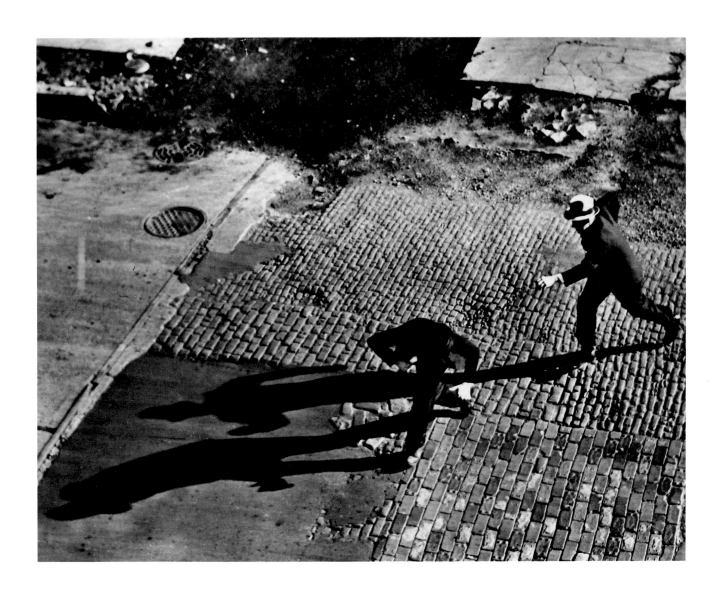

58 | Staged scene with models, 1940
Photographed for U.S. Gypsum,
Chicago

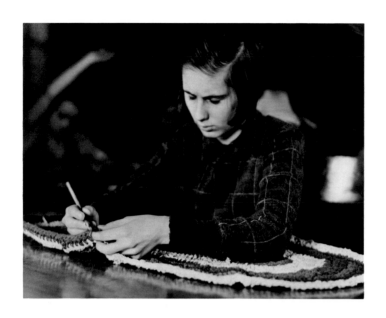

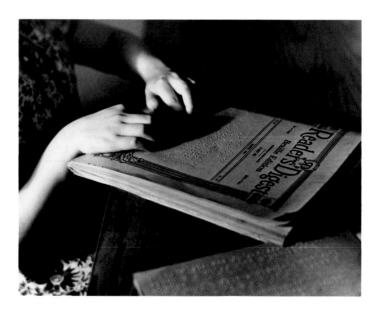

59 | Blind student at special school for
the blind, 1937
Photographed for the Chicago
Board of Education

60 | Blind student reading braille, 1937
Photographed for the Chicago
Board of Education

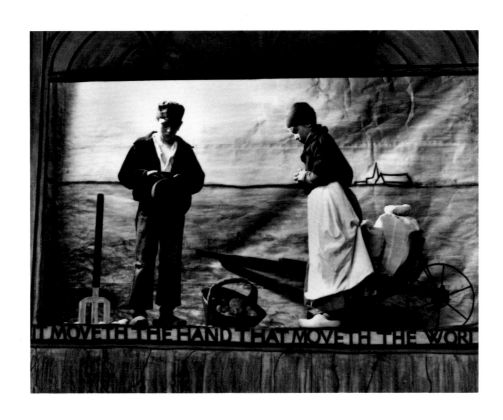

61 | *Tableaux*, grade-school students
enacting an image after a painting by
Jean François Millet, c. 1937
Photographed for the Chicago
Board of Education

62 | People who read the *Sun*, c. 1950
Photographed for Leo Burnett Co.,
Chicago

63 | People who read the *Sun*, c. 1950
Photographed for Leo Burnett Co.,
Chicago

64 | People who read the *Sun,* c. 1950
Photographed for Leo Burnett Co.,
Chicago

65 | People who read the *Sun,* c. 1950
Photographed for Leo Burnett Co.,
Chicago

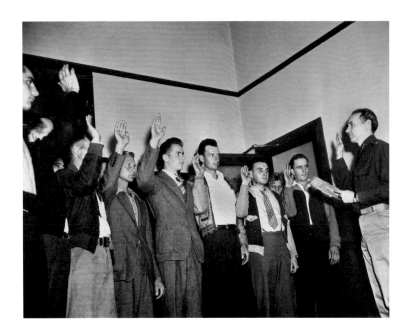

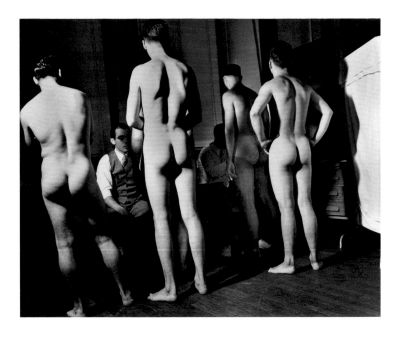

66 | Swearing in new recruits, c. 1940
Originally appeared in *Hygeia*,
Fort Sheridan, Illinois

67 | Recruiting, c. 1940
Originally appeared in *Hygeia*,
Fort Sheridan, Illinois

68 | New recruits being outfitted, c. 1940
Originally appeared in *Hygeia*,
Fort Sheridan, Illinois

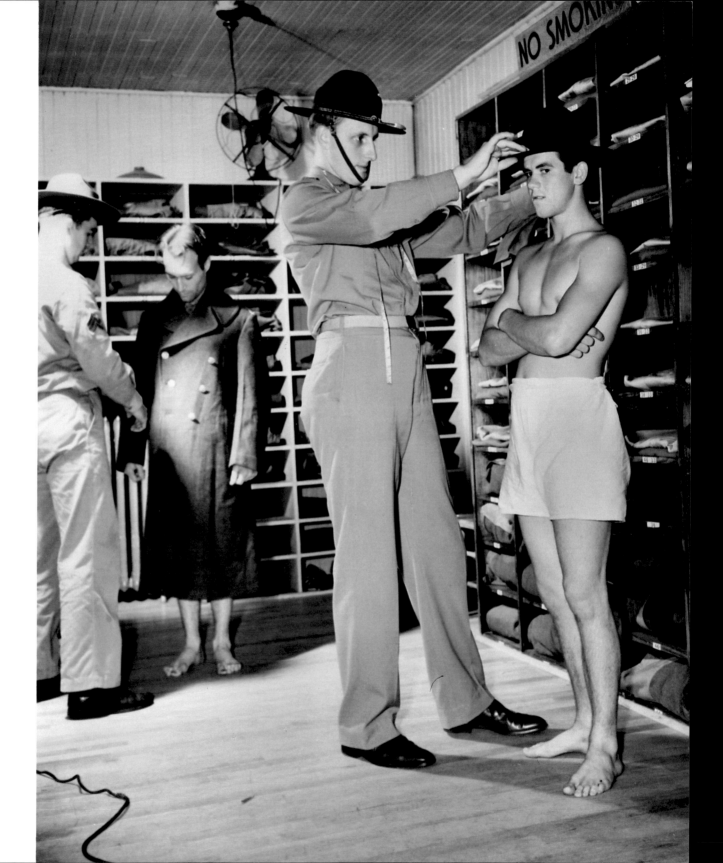

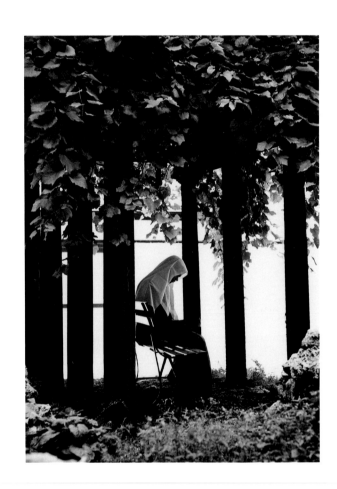

69 | Garden at Monastery of the Poor
 | Clare, c. 1963
 | Photographed for the Monastery,
 | Chicago

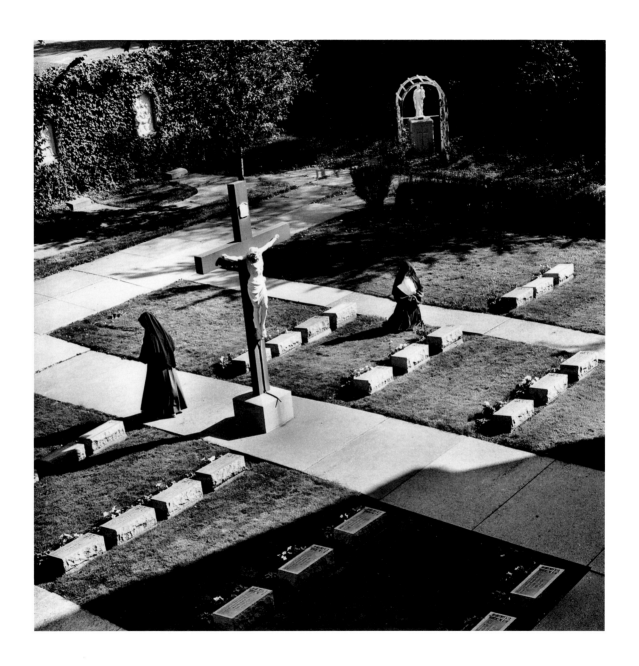

70 | Cemetery at Monastery of the Poor
Clare, c. 1963
Photographed for the Monastery,
Chicago

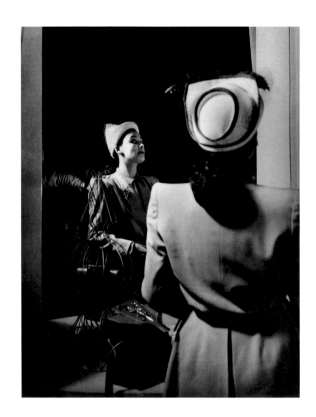

71 | Lena Horne shopping at Marshall
Field's, c. 1950
Originally appeared in *Ebony*, Chicago

72 | Lena Horne resting in bed in hotel
room, c. 1950
Originally appeared in *Ebony*, Chicago

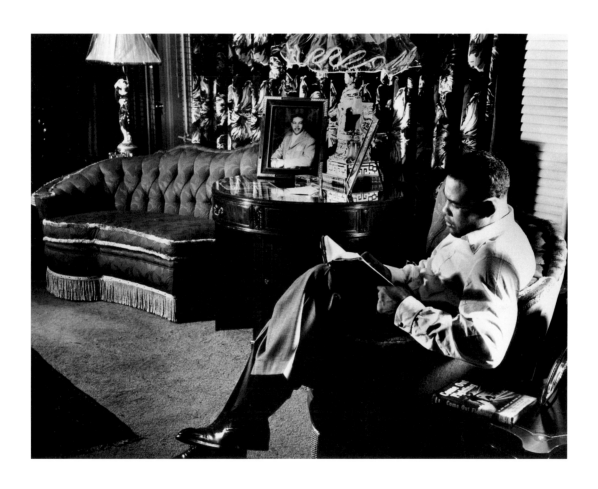

73 | Joe Louis at home, 1949
Originally appeared in *Ebony*, Chicago

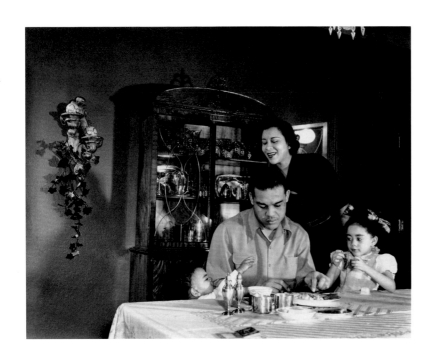

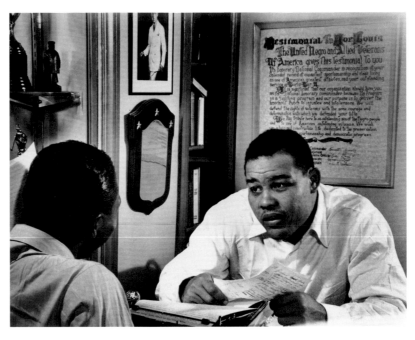

74 | Joe Louis, his wife Marva,
and two children, 1949
Originally appeared in *Ebony*, Chicago

75 | Joe Louis, 1949
Originally appeared in *Ebony*, Chicago

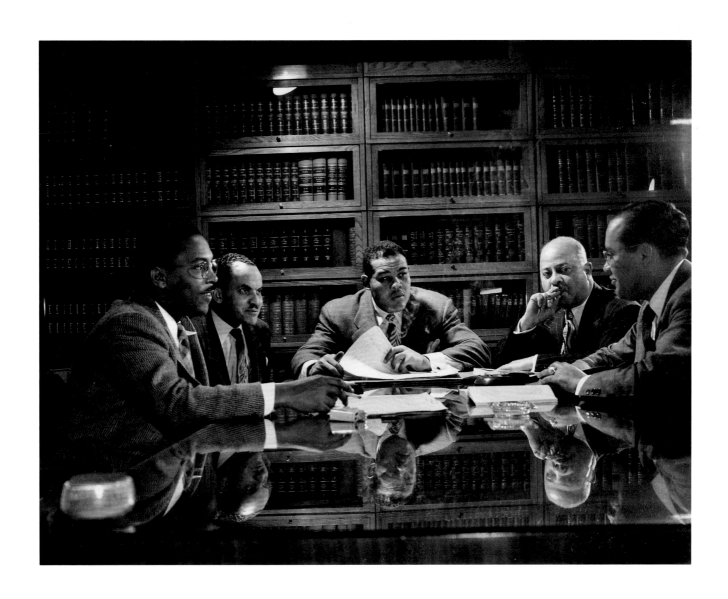

76 | Joe Louis and his "Brain Trust," 1949
Originally appeared in *Ebony*, Chicago

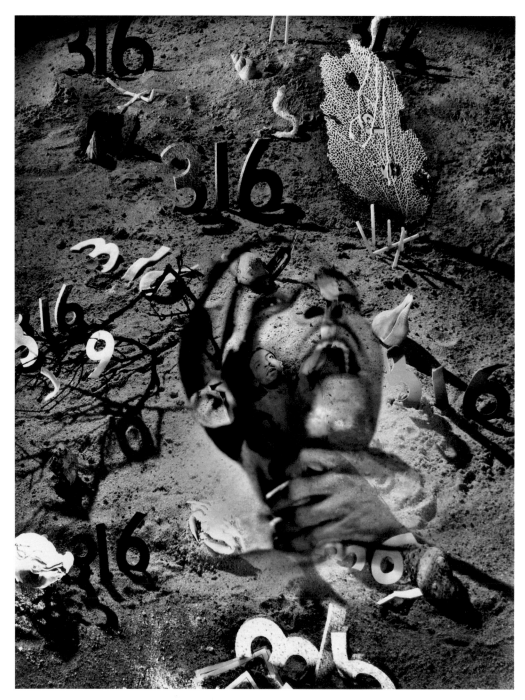

77 | *Numbergame*, c. 1950
Originally illustrated "What Negroes
Dream About" in *Ebony*, Chicago

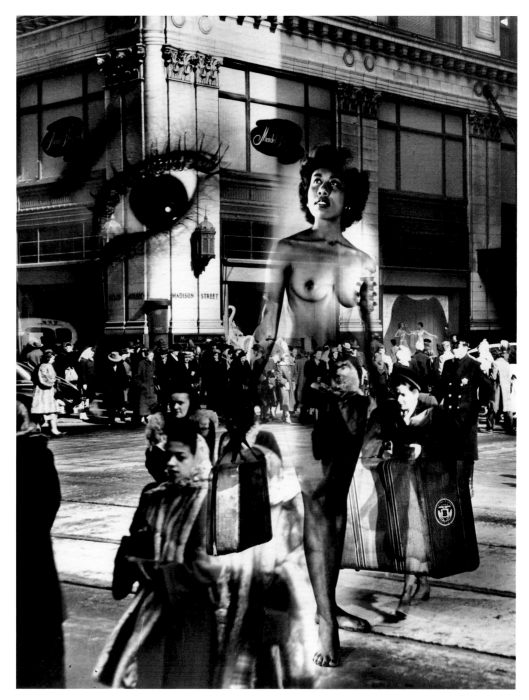

78 | *State and Madison,* c. 1950
Originally illustrated "What Negroes
Dream About" in *Ebony*, Chicago

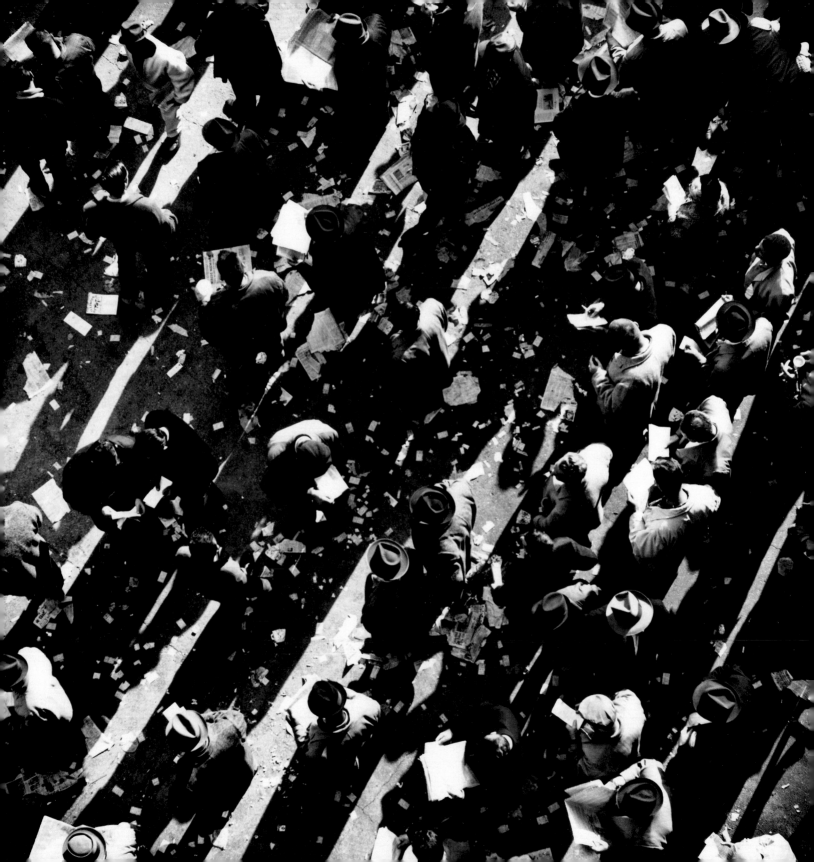

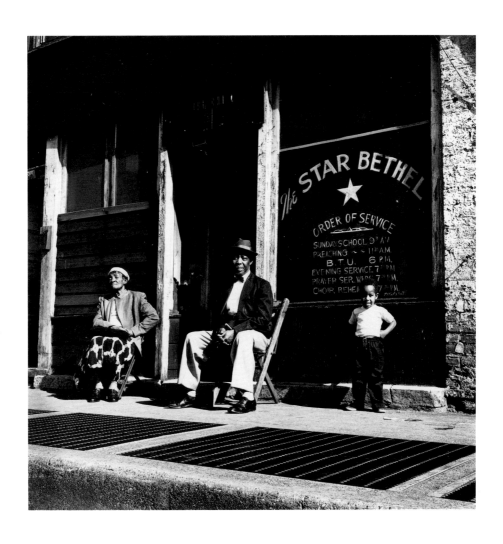

79 | *Win Some—Lose Most*, 1963
Arlington Park Racetrack,
Arlington Heights, Illinois

80 | "Doors and Windows" series, c. 1950
Clybourn Avenue near Division Street,
Chicago

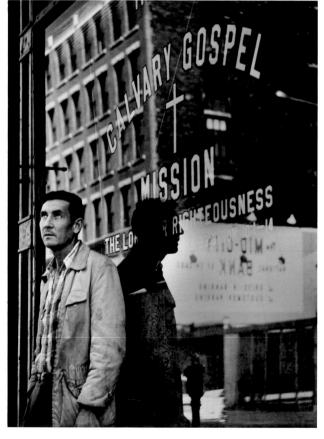

81 | "Doors and Windows" series, c. 1950
South Side of Chicago

82 | "Doors and Windows" series, c. 1950
Off Skid Row, Chicago

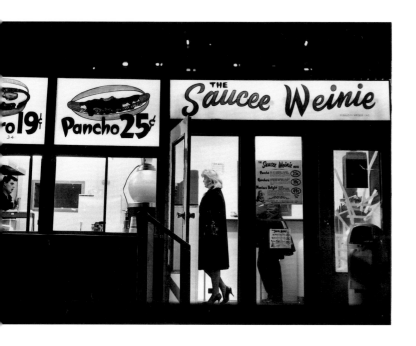

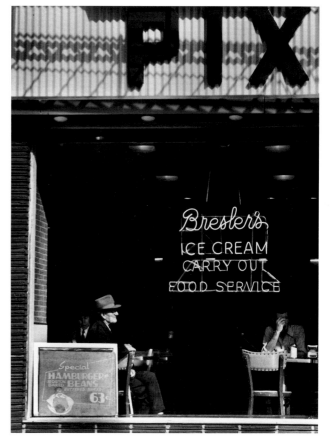

83 | *Late Night,*
| "Doors and Windows" series, c. 1955
| Dearborn Street near Randolph Street,
| Chicago

84 | *A Cup of Coffee,*
| "Doors and Windows" series, c. 1940
| Chicago Avenue near Clark Street,
| Chicago

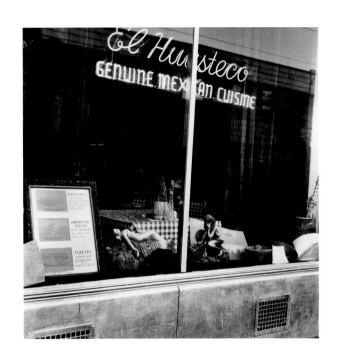

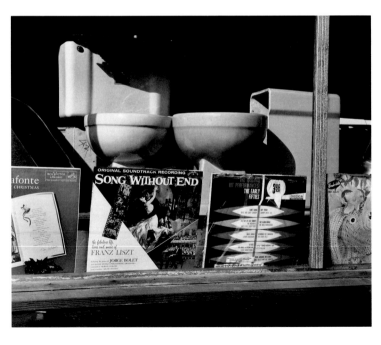

85 | *Art and Food,*
| "Doors and Windows" series, c. 1960
| State Street near Grand Avenue,
| Chicago

86 | *Song Without End,*
| "Doors and Windows" series, c. 1960
| Halsted Street near 20th Street,
| Chicago

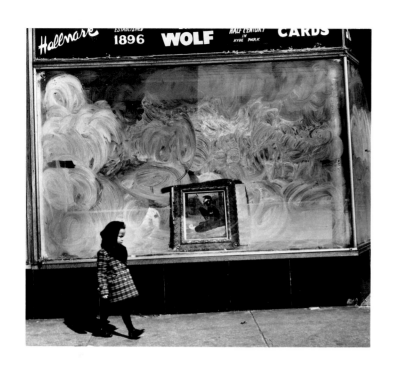

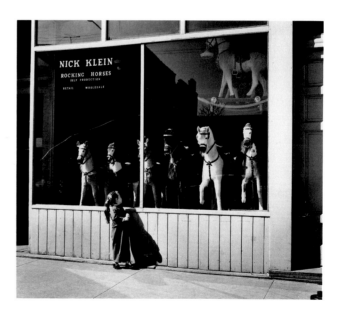

87 | "Doors and Windows" series, c. 1960
South Side of Chicago

88 | "Doors and Windows" series
Lincoln Avenue near
Fullerton Parkway, Chicago

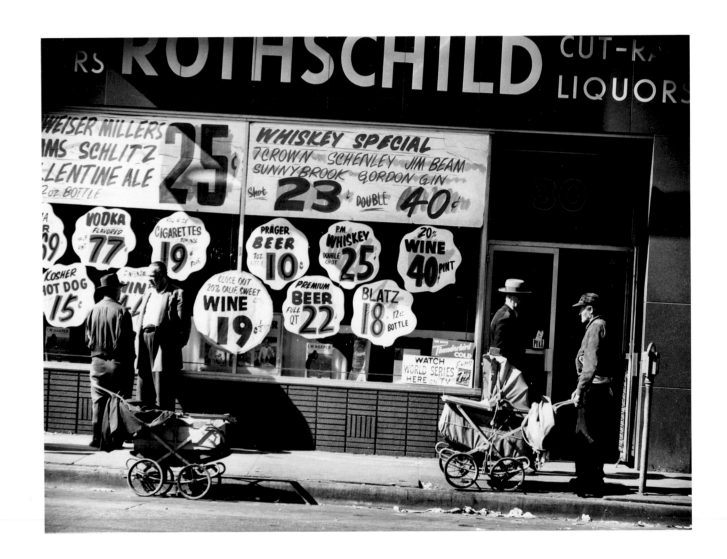

89 | "Doors and Windows" series, 1960
Halsted Street near Madison Street,
Chicago

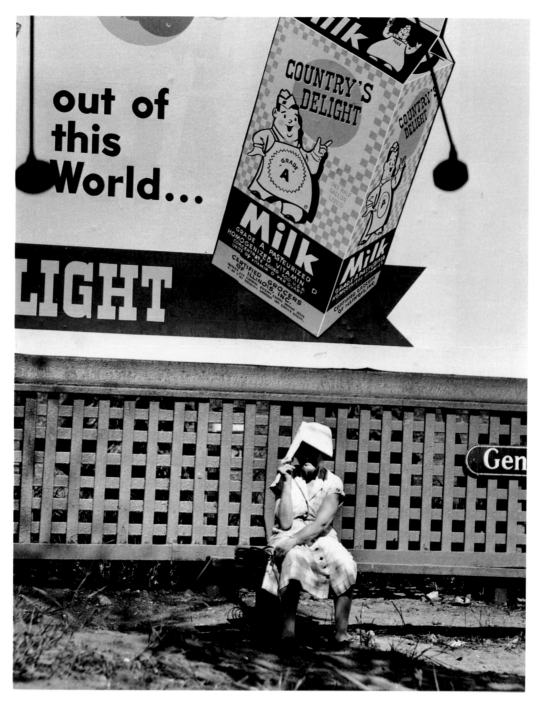

90 | "Bench Sitters" series, c. 1955
Chicago

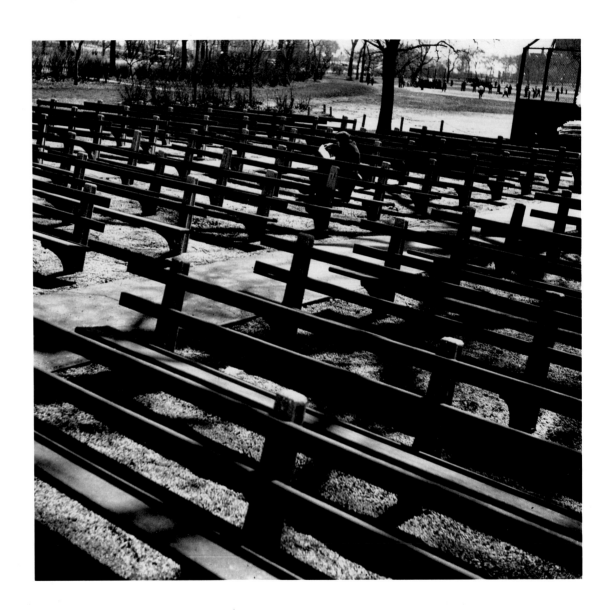

91 | "Bench Sitters" series, c. 1940
Chicago

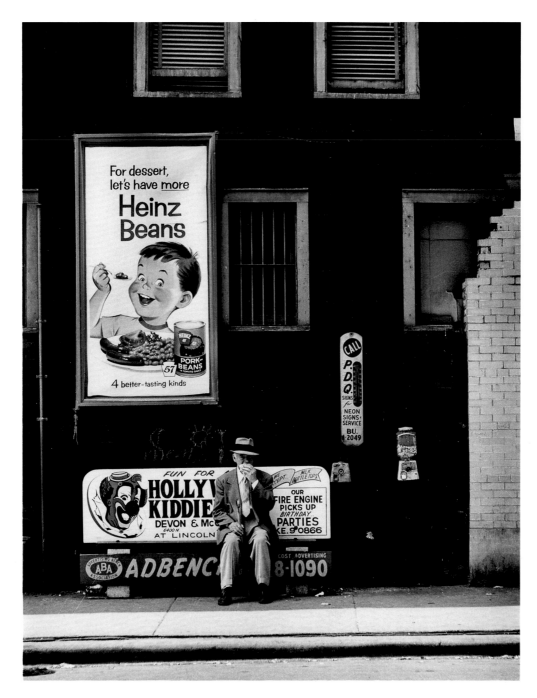

92 | "Bench Sitters" series, c. 1955
Chicago

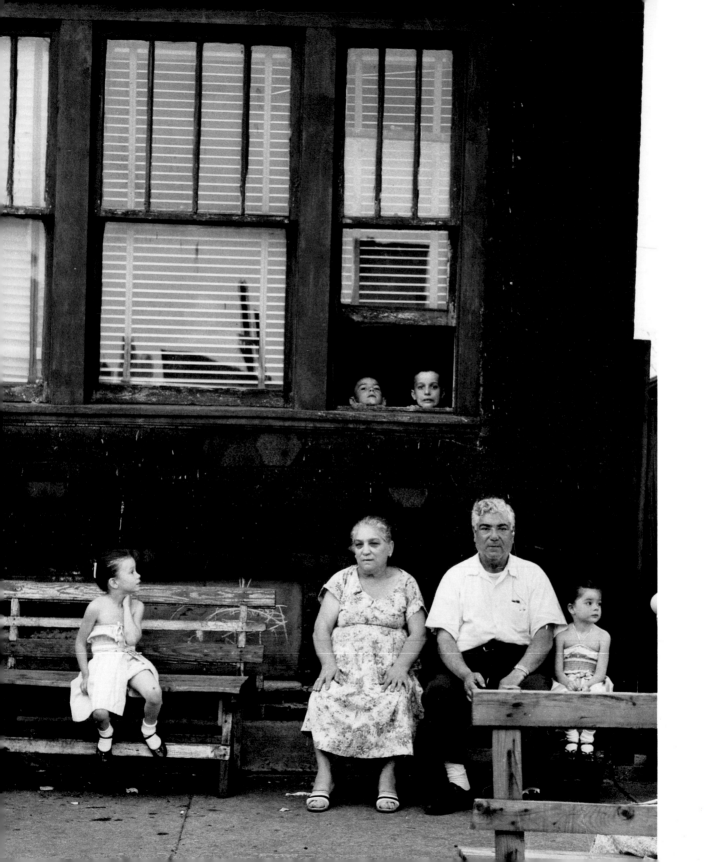

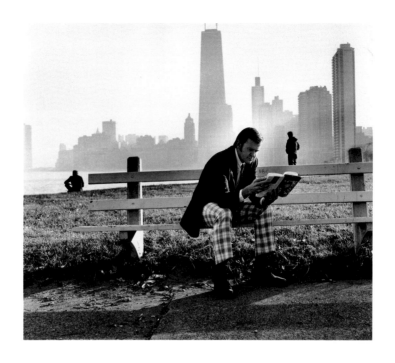

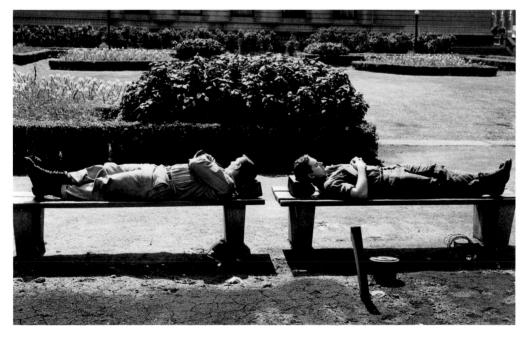

93 | "Bench Sitters" series, c. 1950
Chicago

94 | "Bench Sitters" series, c. 1955
Chicago

95 | "Bench Sitters" series, c. 1970
Chicago

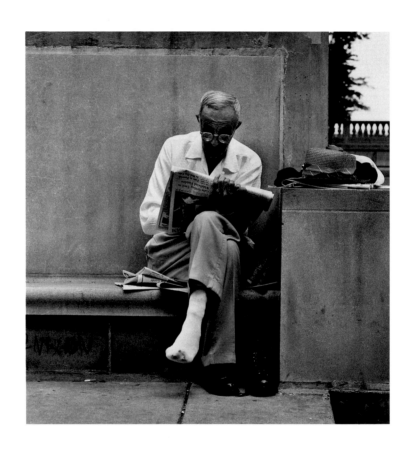

96 | "Bench Sitters" series, c. 1955
Chicago

97 | *It Never Stops Hurting,*
"Twilight World" series, 1964-65
Dixon School for the Mentally
Retarded, Dixon, Illinois

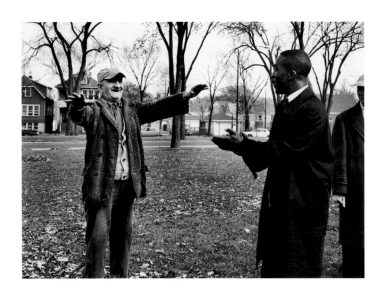

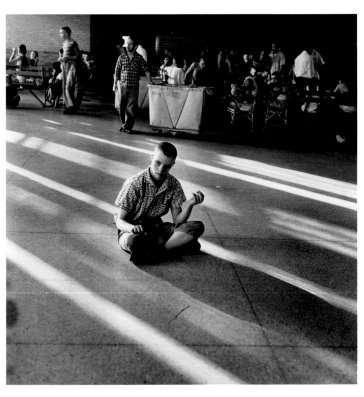

98 | *A Moment of Joy,*
"Twilight World" series, 1964-65
Dixon School for the Mentally
Retarded, Dixon, Illinois

99 | *Frozen Motion,*
"Twilight World" series, 1964-65
Dixon School for the Mentally
Retarded, Dixon, Illinois

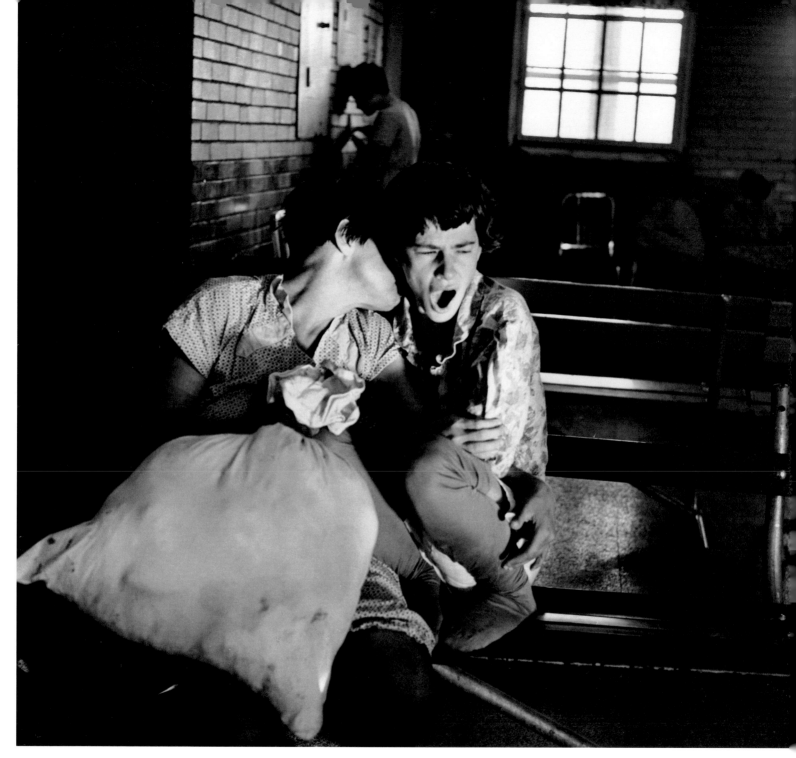

100 | *Living Statue,*
"Twilight World" series, 1964-65
Dixon School for the Mentally
Retarded, Dixon, Illinois

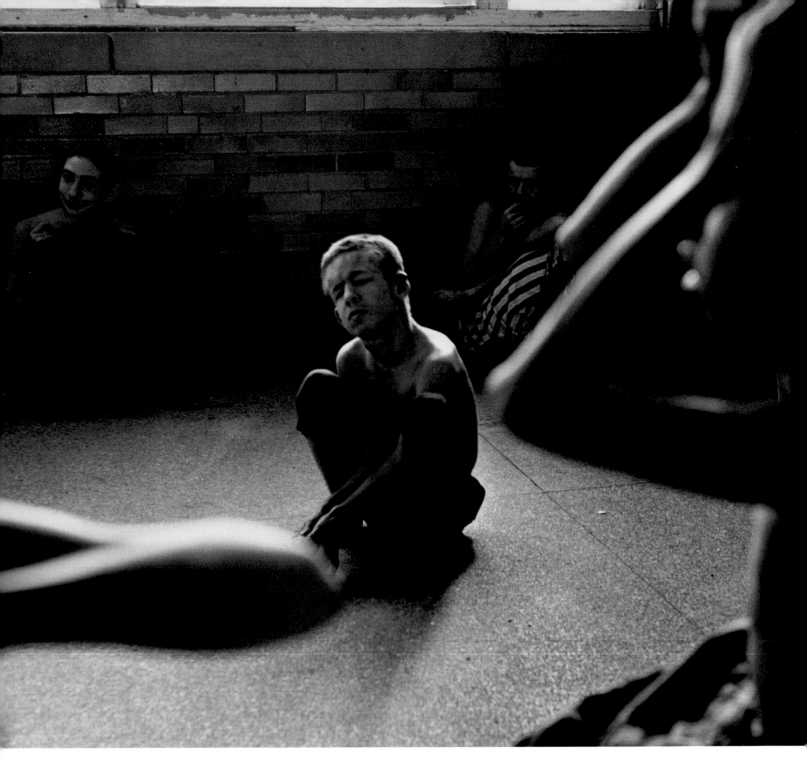

101 | *No One Hears the Scream,*
"Twilight World" series, 1964-65
Dixon School for the Mentally
Retarded, Dixon, Illinois

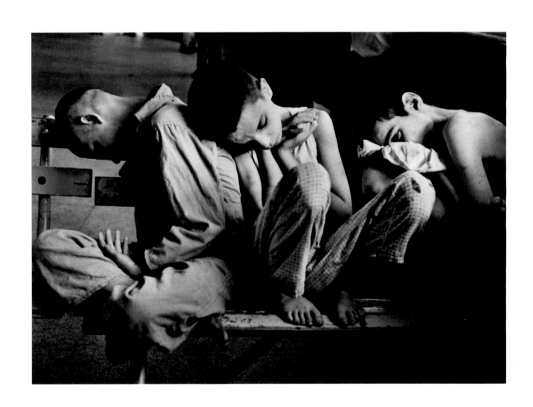

102 | *All Alone Together,*
"Twilight World" series, 1964-65
Dixon School for the Mentally
Retarded, Dixon, Illinois

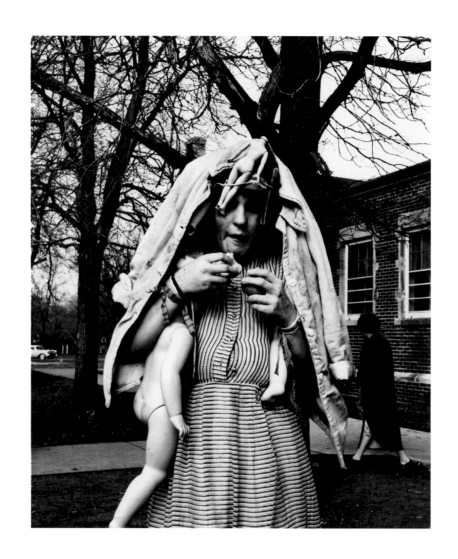

103 | *Me and My Friends,*
"Twilight World" series, 1964-65
Dixon School for the Mentally
Retarded, Dixon, Illinois

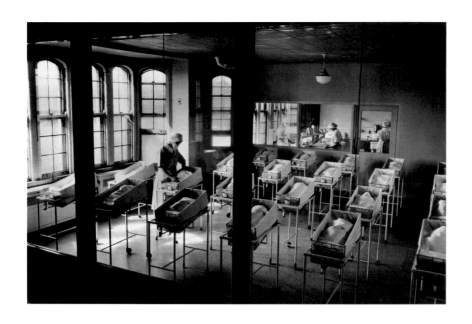

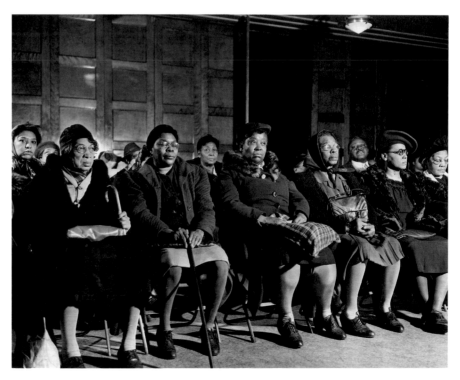

104 | Nursery at the Chicago Lying-In
Hospital branch of Billings
Hospital, c. 1955
Photographed for the University
of Chicago

105 | Outpatient visiting at Provident
Hospital, c. 1955
Originally appeared in *Ebony*,
East 51st Street, Chicago

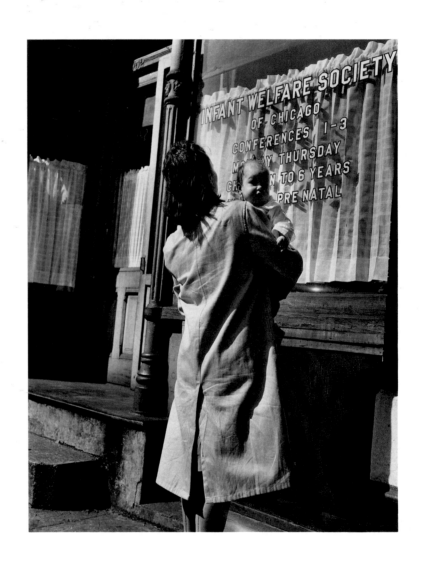

106 | Infant Welfare Society, c. 1955
South Halsted Street, Chicago

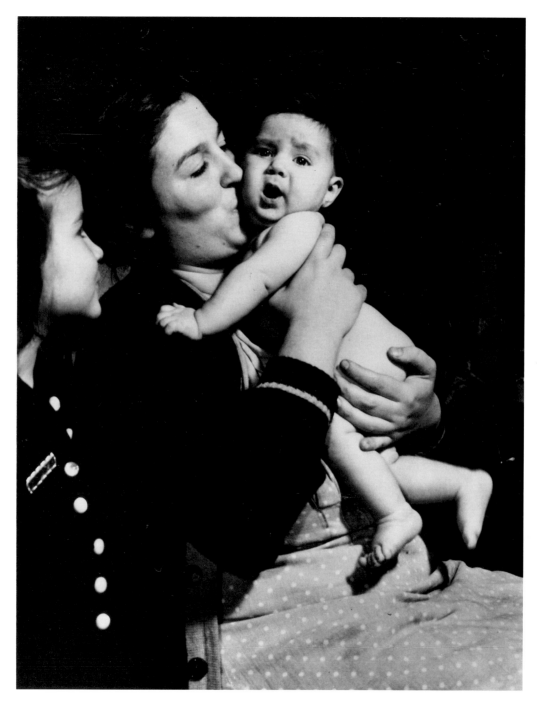

107 | Mother with children at an
Infant Welfare Station, c. 1955
South Halsted Street, Chicago

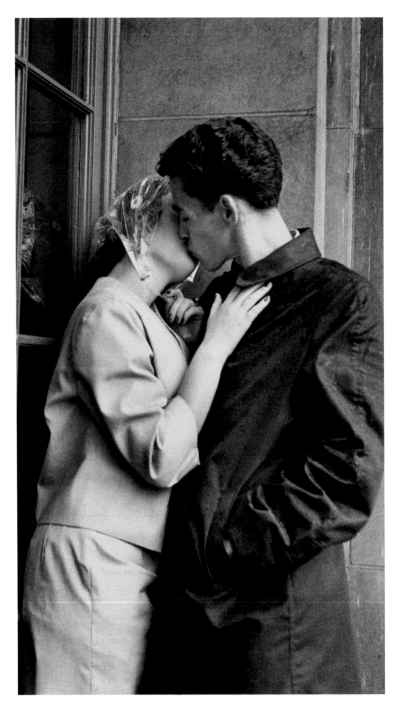

108 | Art Institute of Chicago students at
the Goodman Theater entrance, c. 1955
Chicago

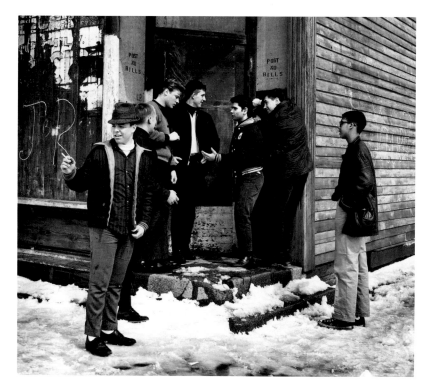

109 | *Hanging Out*, c. 1968
Photographed for Henry Regnery
Publishing Co., Southwest Side of
Chicago

110 | *Hanging Out*, c. 1965
Aldine Avenue near Halsted Street,
Chicago

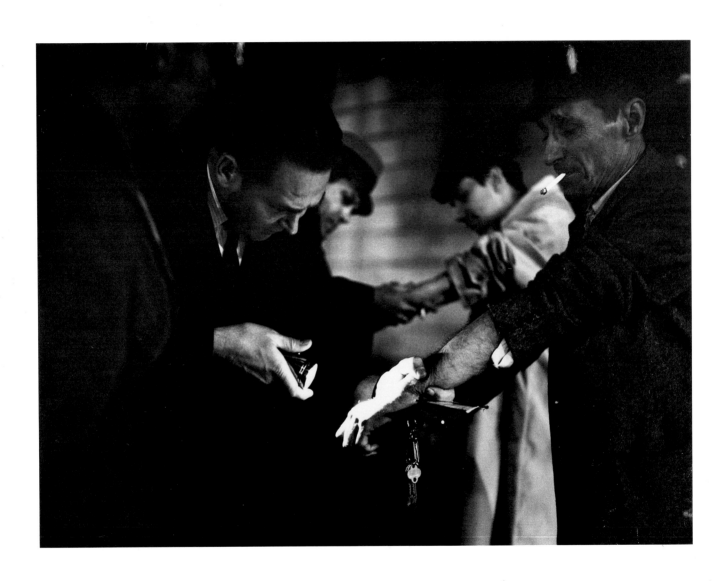

111 | *Let's Look*, narcotics squad investigating
suspects, 1961
State Street near Chestnut Street,
Chicago

112 | Pool hall, 1960
Clark Street at Erie Street, Chicago

113 | *Arrest*, prostitute being investigated,
1961
Wells and Superior Streets, Chicago

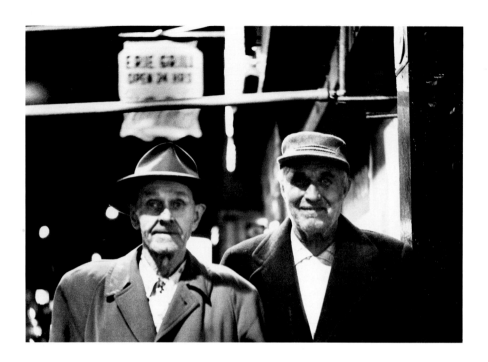

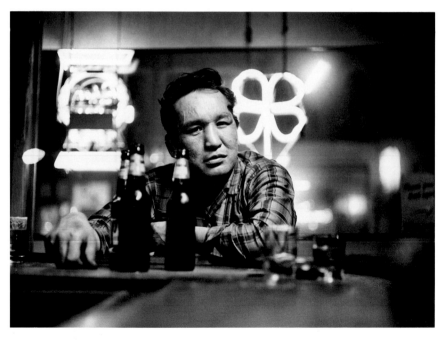

114 | *Between Drinks*, 1961
Clark Street near Superior Street, Chicago

115 | *Number Three*, American Indian
in tavern, 1963
Clark Street near Superior Street, Chicago

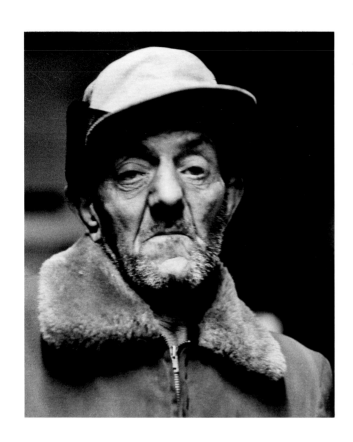

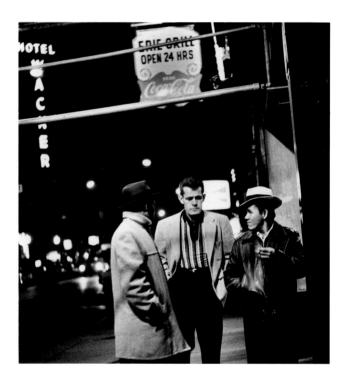

116 | *Thirsty,* 1963
Clark Street near Erie Street, Chicago

117 | *Street People,* 1961
Clark Street near Illinois Street, Chicago

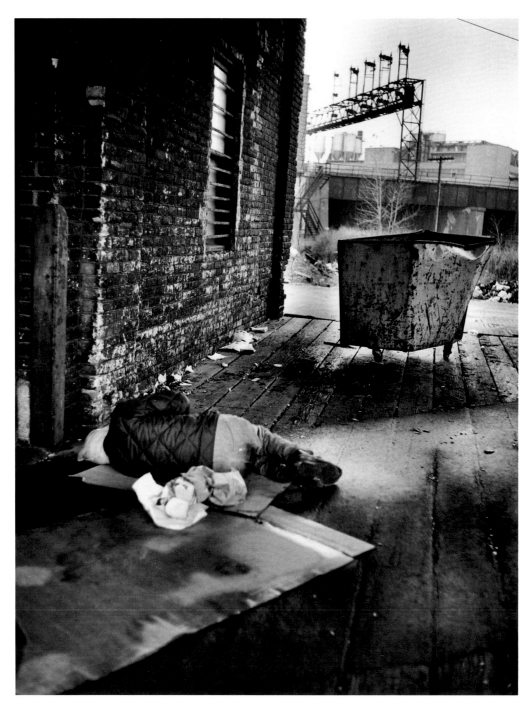

118 | *Home of Homeless*, 1963
Near the north branch of Chicago
River, Chicago

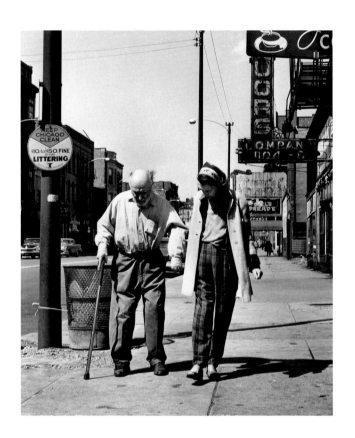

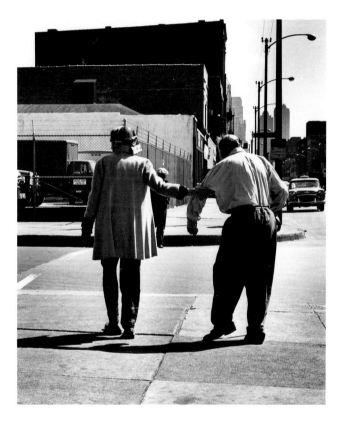

119 | *Steady as He Goes*, 1963
Skid Row, West Madison Street,
Chicago

120 | *Odd Couple*, 1963
Skid Row, West Madison Street,
Chicago

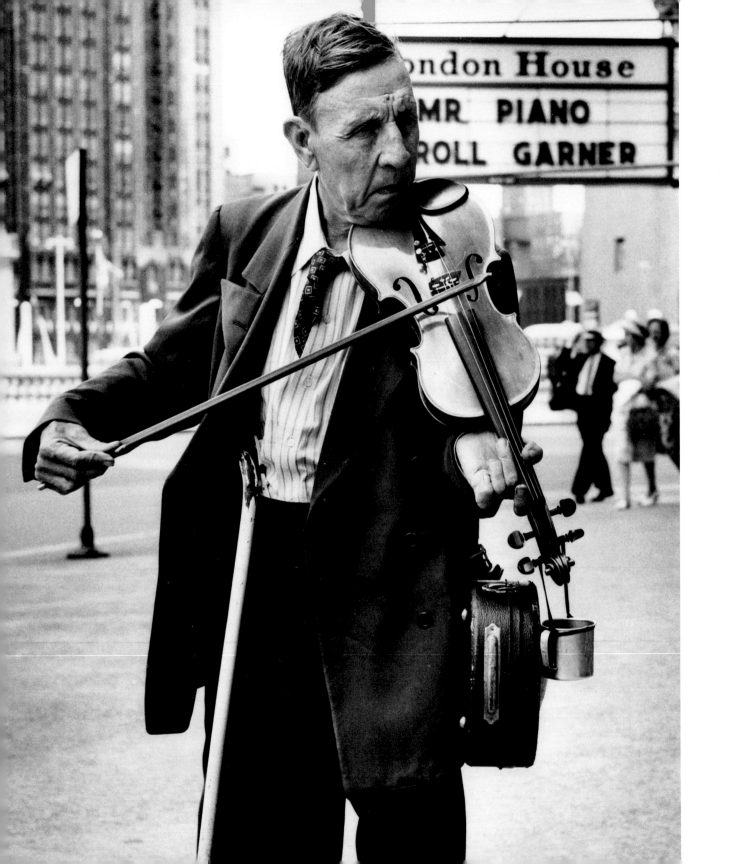

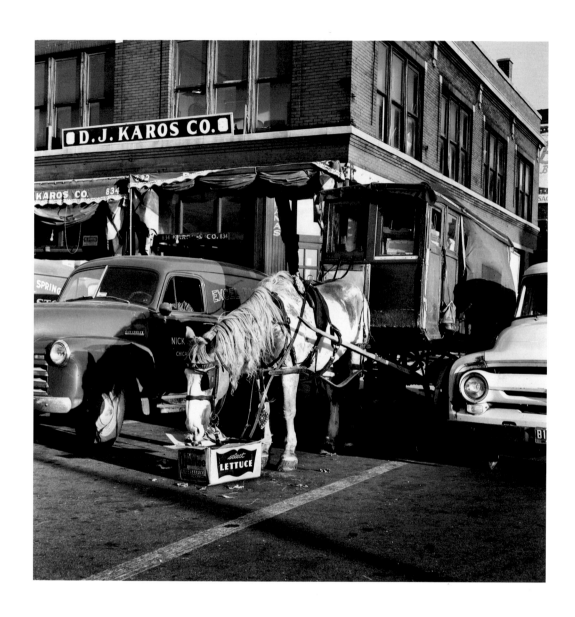

121 | Street concert by "blind" fiddler, c. 1948
Wacker Drive at Michigan Avenue,
Chicago

122 | *Lunchtime*, produce-workers' wagon at
South Water Produce Market, c. 1950
Randolph Street near Halsted Street,
Chicago

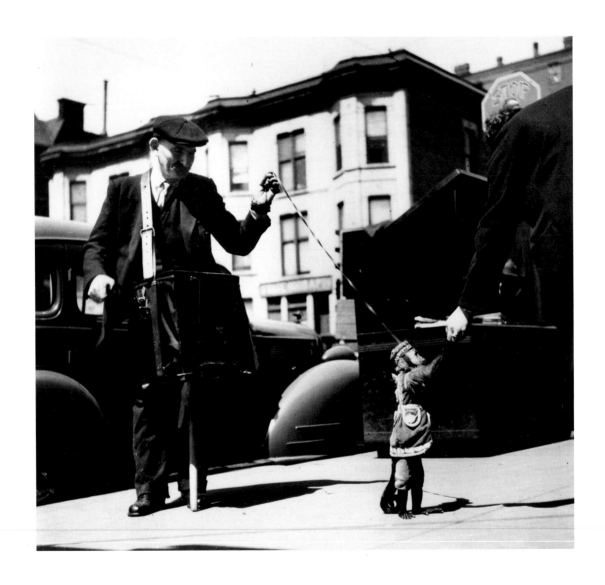

123 | *Old Sicilian Organ Grinder*, c. 1945
Near State and Ontario Streets,
Chicago

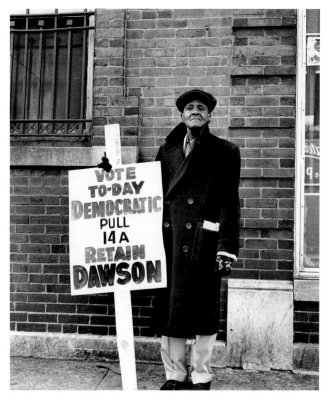

124 | *Long Live...*, African demonstrators, c. 1963
Near North Michigan Avenue Bridge, Chicago

125 | *Campaigning*, 1964
South Side of Chicago

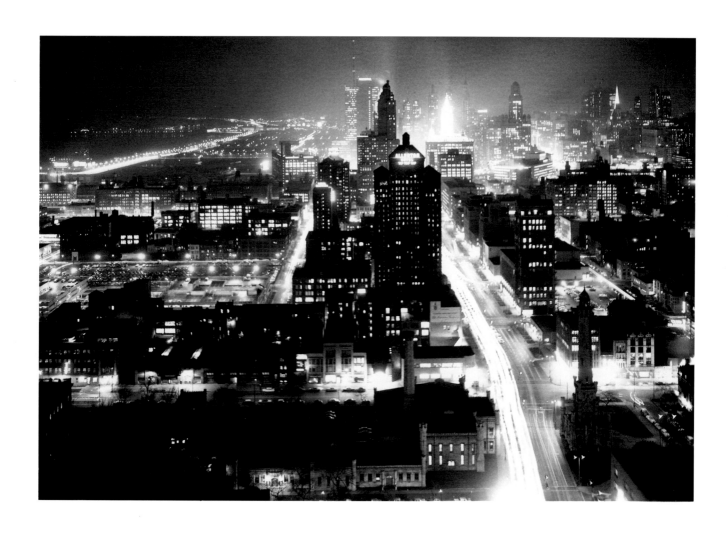

126 | *The Boss*, 1964
South Side polling station, Chicago

127 | *Chicago at Night*, c. 1940
North Michigan Avenue, Chicago

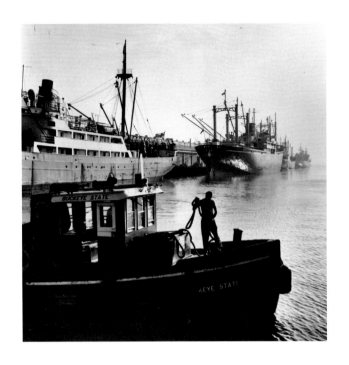

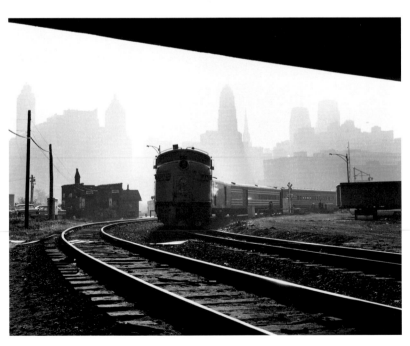

128 | *Navy Pier*, c. 1960
Chicago

129 | *Leaving Chicago*, c. 1940
Switching yard near West Illinois Street,
Chicago

130 | *Garage*, c. 1945
Wacker Drive at State Street, Chicago

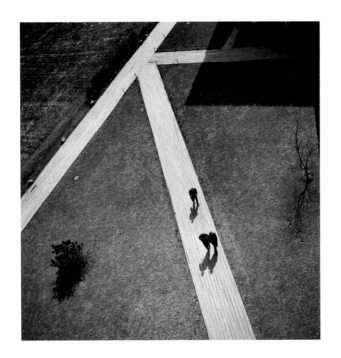

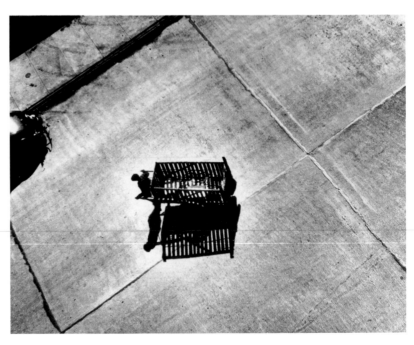

131 | *Changing Classes,*
Lane Tech High School, 1938
Photographed for the Chicago Board
of Education

132 | *Early Morning,* 1938
Dearborn Street at Grand Avenue,
Chicago

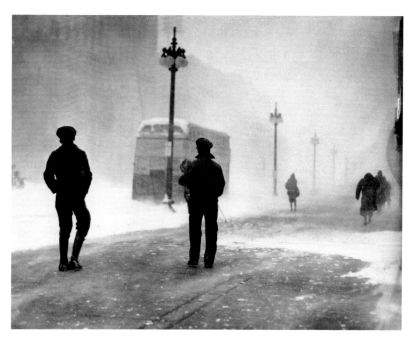

133 | *After Snow Storm*, c. 1943
Michigan Avenue at Wacker Drive,
Chicago

134 | *Blizzard*, c. 1943
Michigan Avenue at Wacker Drive,
Chicago

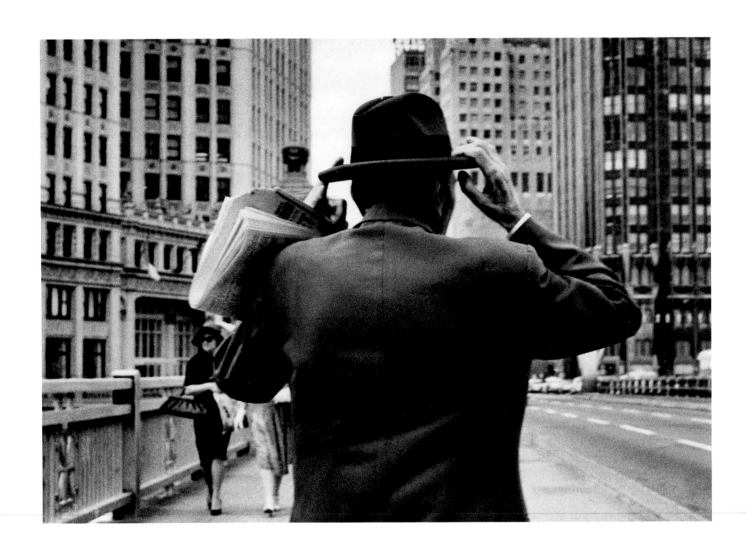

135 | *Windy City*, c. 1953
North Michigan Avenue Bridge,
Chicago

136 | *Emmanuelle*, 1975
Paris

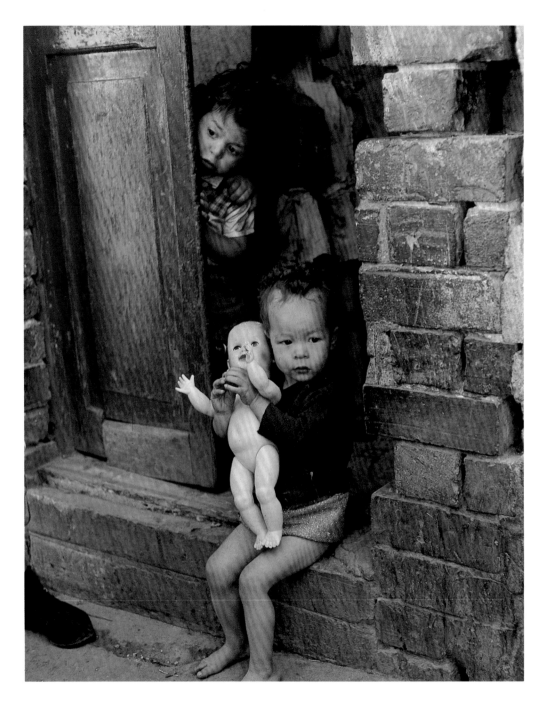

137 | *Three Dolls*, 1971
Bogota, Colombia

138 | *In the Ghetto,* 1969
Rome

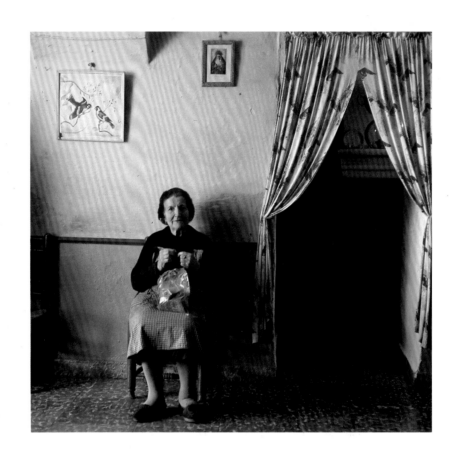

139 | *Cave Dweller*, 1970
 Gaudix, Spain

140 | *Sheep*, 1969
 Passo Eclano, Sicily

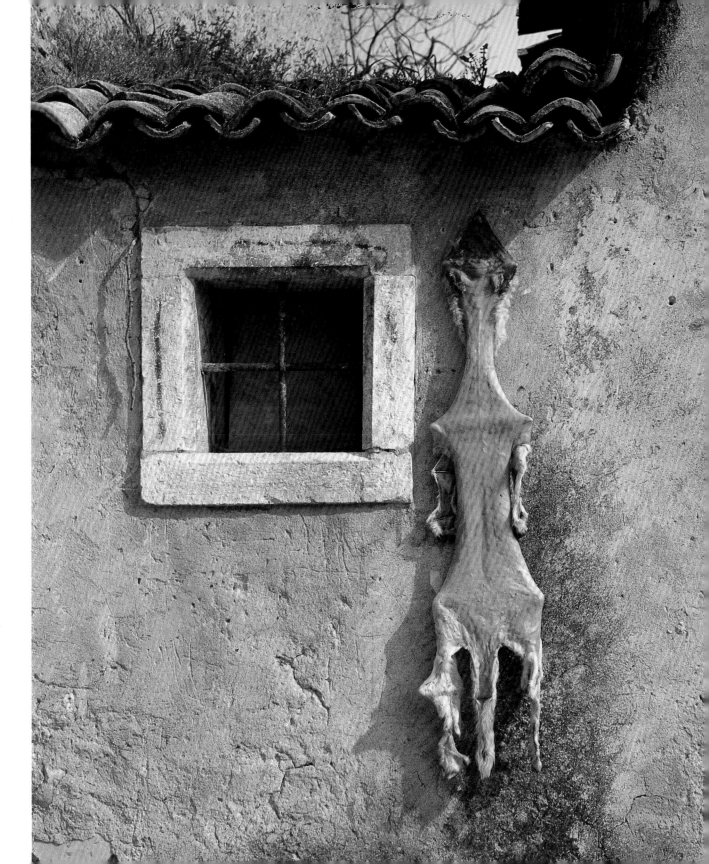

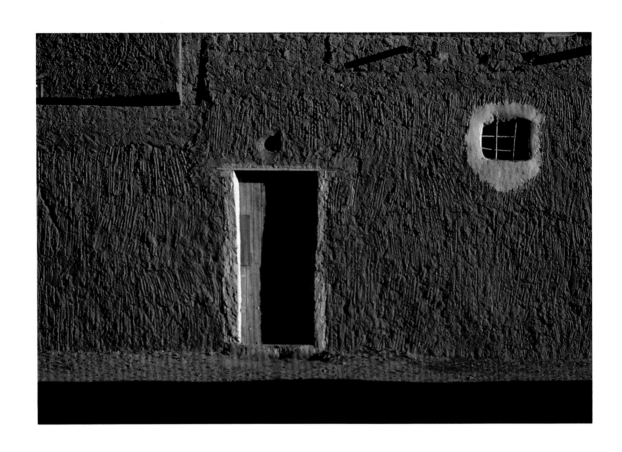

141 | *Wall with Door and Window,* 1977
Tamanrasset, Algiers

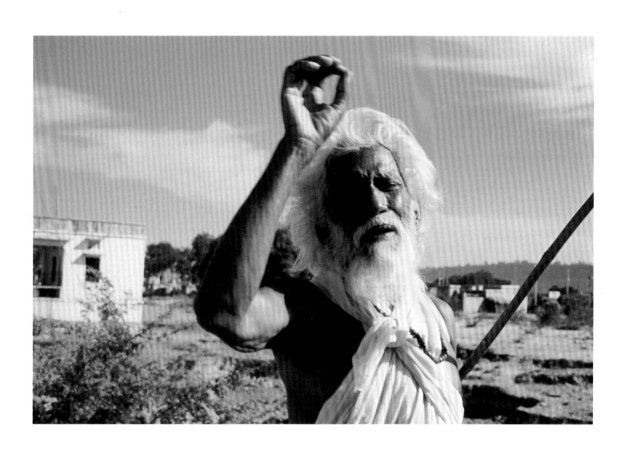

142 | *Holy Man,* 1972
Central India

143 | *Au Revoir*, 1987
Buttechaumont, Paris

Stephen Deutch: Chronology

1908
Born January 14 in Budapest, Hungary, to Julius and Johanna Deutsch. Stephen Deutch dropped the "s" from the name when he moved to Chicago.

1923-1926
Completes three-year apprenticeship as a woodcarver in Budapest. Exhibits sculpture in several group shows.

1926-1927
Studies sculpture at the Royal Academy of Fine Arts, Budapest, sculpting in clay and wood.

1927
Moves to Paris. Works as a woodcarver for a furniture factory. Exhibits sculpture at the "Salon Independent" and in other group shows.

1930
Works as a salesman for an import-export firm. Company sends him across Europe and into Africa where he immerses and educates himself in art history by visiting museums, churches, historic buildings and libraries.

1931
Marries Helene Beck.

1932-1936
Joins Helene in the photography studio business she takes over. She teaches him photography. They operate the H. E. Deutsch Studio Photographique at 9 Rue de Montsouris, Paris. Deutch initiates lifelong art and documentary projects, photographing nudes, street life and travels. Photographs published in many French publications.

1936
Daughter Annick is born May 11.
The Deutches move to America
and arrive in Chicago in December.

1937
Deutch and Helene open a commercial studio at 510 North Dearborn
Street. *Coronet* begins publishing his
photographs and continues to publish large selections of them over
the next eight years.

1938
The studio moves to 75 East Wacker
Drive where it will remain for forty-three years. During those years, his
editorial photographs and photo
essays appear in *Coronet*, *Ebony*,
Fortune, *Negro Digest*, *Popular
Photography*, the *Saturday Evening
Post*, *Chicago* magazine, the Chicago
newspapers, and other publications.

A commercial assignment to photograph the Chicago public schools
brings Deutch into the neighborhoods where he resumes his street
photography. He and Helene travel
to Mexico and both take photographs. They sell enough of them to
Coronet and other publications to
pay for the trip. The Chicago Public
Library exhibits both Deutch's and
Helene's Mexico photographs. The
show travels to Toronto, Omaha and

other cities. The Art Institute of
Chicago exhibits two pieces of his
sculpture in a group show.
Daughter Katherine (Kathy)
is born August 15.

1940
Deutch handles all types of commercial photography with fashion photography representing eighty percent
of the studio's business by the late
1940's. He begins to enter photographs in advertising shows and wins
approximately forty awards over the
next thirty years.

1943
Daughter Carole is born December
23. Helene leaves the business.

1950
The Deutches move to the suburb
of Wilmette and live there for ten
years.

1959
"Bench Sitters" exhibition at the
Chicago Public Library.

1962
"Doors and Windows" exhibition at
the Art Institute of Chicago. Several
of the exhibit photographs are in
the museum's permanent collection.

The WTTW public television series
Festival does a show on "Doors and
Windows" and "Bench Sitters."
A second *Festival* show taped for

national distribution features Deutch's photographs of Chicago. It appears on several public television stations.

1965

"Twilight World" exposé on conditions in Illinois mental hospitals is initiated by Deutch's photographs. The series runs for five consecutive days in the *Chicago Daily News*. Deutch is nominated for a Pulitzer Prize. Public-health organizations sponsor exhibitions of the photographs nationwide.

Deutch and Helene begin to travel around the world. Deutch, who worked in both color and black-and-white commercially, shifts to color film for his travel photography.

1979

Kathy Deutch Tatlock, a filmmaker, completes the movie *Pista: The Many Faces of Stephen Deutch*. The movie is previewed in Chicago at a private showing and is aired in 1981 on WTTW public television.

1980

The Chicago Historical Society acquires a large selection of Deutch's prints, negatives, contact sheets, tearsheets, correspondence and other documents for a permanent archive.

1981

"Faces and Places" exhibition of color travel photographs at the Chicago Public Library Cultural Center.

Deutch moves to another studio at 114 West Illinois Street when the 75 East Wacker building is gutted and renovated.

1983

"Nelson Algren and His Chicago" exhibition at the North Light Theater. Deutch closes his studio, though he continues to do some commercial work until 1986. He devotes increasing amounts of time to sculpture at the studio of his home in Sawyer, Michigan.

1984-1985

Portfolios of prints published by *TriQuarterly* magazine, *Chicago* magazine and in Studs Terkel's *Chicago*.

1989

The Chicago Historical Society acquires a second large body of prints, negatives, contact sheets and documents for the Deutch archive. Deutch and Helene split their weeks between Sawyer and Chicago. Recent sculpture is in several private collections.

Retrospective exhibition at the Chicago Public Library Cultural Center, sponsored jointly by the Chicago Office of Fine Arts and the Chicago Historical Society.

Designed by Raymond S. Machura

Composed by Publishers Typesetters, Inc.
in Berling

Printed by Meriden-Stinehour Press on
Warren's Lustro Dull